Ground Time

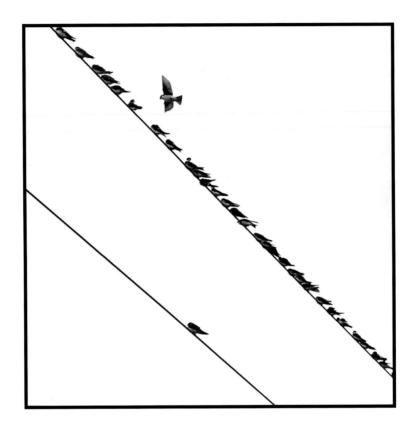

DELAWARE, 1972

Ground Time

Slightly Upbeat Street Shooting from Around and Around the World

KENT RENO

Foreword by
ELLIOTT ERWITT

Edited by
ROBERT McDONALD

CUSTOM & LIMITED EDITIONS
San Francisco

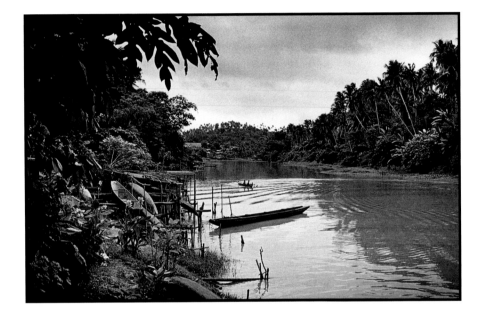

PHILIPPINES, 1971

First Printing

Designed by Morris Jackson

ISBN: 1-881529-50-9

Library of Congress Number: 98-71704

Published by
CUSTOM & LIMITED EDITIONS
San Francisco, California

Printed in Italy

To all the people I've photographed before

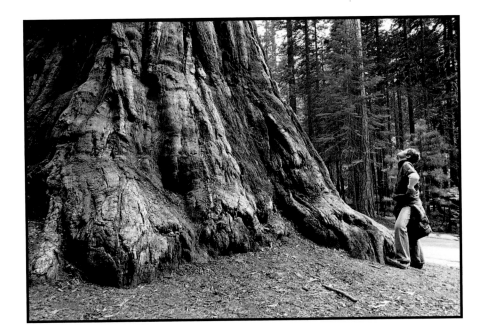

CALIFORNIA, 1978

Acknowledgments

From the moment that I first began taking pictures nearly thirty years ago my journey has been made easier through the assistance of countless individuals. I am most grateful to them.

The following people, who were in various ways involved in the making of this book, have my special appreciation and thanks:

Stuart Kenter, of Stuart Allen Books, for jump-starting my interest in doing this book,

Bill Shilling, my long time friend, for his spirited encouragement and never-ending flow of imaginative ideas,

Robert McDonald, Editor, for his way with words and for reminding me of the usefulness of diagraming sentences,

Morris Jackson, Designer, for his impeccable sense of form and structure and his flexibility in fielding my sometimes off-the-wall design concepts,

Ron Fouts, of Custom & Limited Editions, for his dedication to fine books and his role in putting it all together,

Elliott Erwitt, whose photographic eye and whose wit I have long admired, for his very intelligent, perceptive and generous Foreword,

Fern, Jeffery and Jennifer, my wife, son and daughter, for their understanding and support of my infatuation with photography,

And, of course, not to be overlooked, my former best girlfriend, Bonnie, our recently departed canine of undetermined ancestry, and Big Ralph, our feline interloper and current King of the Household, for tolerating, though probably never completely understanding, the countless photo sessions.

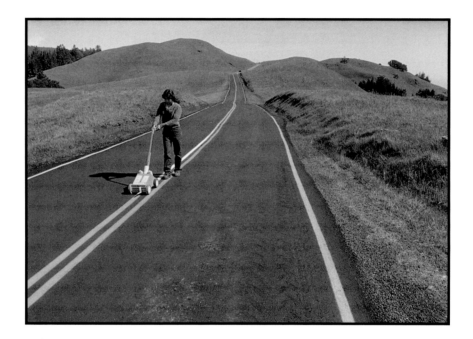

MARIN COUNTY, CALIFORNIA, 1984

Foreword

As a category, most of the photographers I have known are a very serious lot. Especially the journalists who photograph the real world — as opposed to the illustrators, advertisers, pornographers and other commercial types, along with the conceptualizers, who dominate the current photographic scene. In the commercial photographic world one can find a bit of lightheartedness among its practitioners, sometimes, as it exists in many professions. On the other hand, documentarians who do the more significant work are vastly outnumbered by their commercial colleagues and are often too sadly humorless and too deadly serious about being serious.

On the social level I find the commercial category more agreeable. If the commercial boys and girls are successful, they are probably fine craftspeople, professionals who earn an honest workaday living, paying their house mortgage on time and sending their kids to college. Solid citizens. They may possess a sense of humor, though it may seldom emerge in the work due to the strictures of their briefs. As I see it, the bulk of our profession is most closely associated with dentistry as far as laughs go, while the journalistic branch of it is steeped in gravity more in the line of brain surgery.

Ah! for the gifted individual not beholden to any client, one who does not need to prove anything and is not compelled to validate either compulsive or manufactured sincerity. And a double Ah! for the rare photographer who is only interested in what he or she sees with no client on his back, but who, with a keen curiosity and a wink and an irreverent look, can translate those fleeting looks into good photographs.

Kent Reno is a very fine winker, of course. More power to him! He falls in the best category of all for producing work that can be truly quirky and very personal. May he be cloned for our viewing pleasure in years to come! So, when you have digested and marveled at this unusual book, go out and buy additional copies for your friends — and encourage them to do the same. *Ground Time* is a unique glance at the human condition and well deserves our interest.

— Elliott Erwitt

Introduction

Street shooting, also known as street photography, means different things to different people. I define it for myself less by where it takes place—which, even then, isn't always on the street—than by what it requires: a camera, a watchful pair of eyes and an appreciation for the world as a multitude of visually stimulating experiences. It also helps to have a sense of humor and a predilection for incongruities. Street shooting is as simple as being out and about with a camera, observing the ordinary, and being alert for moments of strong visual impact and capturing them wherever they appear.

Ironically, my affair with this eclectic form of photography began at 35,000 feet somewhere in the air over Canada.

It was 1969 and I was flying westward en route for the Far East. Until then I'd never much concerned myself with photography. During sixteen years in the United States Air Force I'd traveled extensively, and I'd had countless photographic opportunities, but I hadn't even owned a camera. This was probably based on my prejudice as a part-time artist who considered painting a superior art form. It might also have been a result of my dislike for camera-toting tourists who

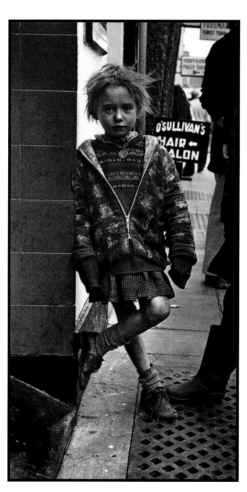

LIMERICK, IRELAND, 1975

constantly pestered people to pose. Whatever the reason, I had absolutely no interest in photography.

But now I was reconsidering. Frustrated by my inability to sketch or paint things I saw on the spot, I toyed with the idea of fixing images on film for later conversion to canvas. When I mentioned to my navigator that I was thinking of buying an Instamatic during our stopover in Anchorage, he responded in his typically droll fashion. A serious amateur photographer himself, he suggested that if I were smart enough to fly a C-141 airplane, I was obviously trainable and could probably eventually be taught to operate a single-lens reflex. He advised me to forget the Instamatic and wait instead until I could pick up a Canon or Nikon in Japan. His advice changed my life.

Many have undergone the transformation that followed. But that didn't diminish the impact on me personally. When you begin to view the world through a camera's lens, your senses sharpen as your mind and eyes are forced to focus on people and on things you never noticed before or thought about. I discovered, even if a picture didn't "happen," even if I didn't find something that was worth shooting,

11

that the simple act of carrying a camera while searching for something to photograph greatly increased my powers of observation and allowed me to experience much more of life.

Eventually I built a basement darkroom and discovered — and rediscovered — the magic of bringing a print to life. I became familiar with the works of Henri Cartier-Bresson, W. Eugene Smith, Robert Doisneau, Elliott Erwitt, and countless others. Completely captivated, I began to understand the excitement of a good photograph.

By the time of my retirement from the Air Force in late 1973, I had set aside my brushes and allowed photography to replace painting in my life. Earlier that year I had taken a portfolio to New York, where I received considerable encouragement, including an exhibition of some of my photographs and an opportunity to work as a photojournalist for *Time* magazine. Shortly thereafter my photograph of a group of foraging deer won the $5,000 Grand Prize in the Kodak International Newspaper Snapshot Competition, which did nothing to dim my enthusiasm.

But then, while preparing to embark on my new career in photography, I received an unexpected call from the Chief Pilot of a West Coast-based supplemental airline offering a chance to fly as a DC-8 Captain on domestic and international charter flights. For someone whose orientation was purely for photography, this might not have presented much of a dilemma. But for me, with twenty years in aviation and a reluctance to calling it quits, this offer was attractive and impossible to ignore. The airline was financially solid and had good equipment; the pay was excellent; and for many reasons the flying promised to be very interesting. There was also the additional incentive of being able to relocate back to my origins in San Francisco. All of these considerations were difficult to brush aside.

Besides, not only could I continue flying, which I greatly enjoyed, but the job seemed to offer a perfect opportunity for combining all-expense-paid, worldwide travel with free-lance photography.

Unfortunately, the ideal was a mirage. Without doubt the new flying job provided plenty of travel to exotic places. Also, the flying itself was often quite challenging, especially getting in and out of the more obscure and less advanced regions of the world. The stretched DC-8 was a large airplane, and even those without a pilot's background will appreciate the difficulties posed by short, ungrooved runways, minimum navigational aids, inadequate weather reports, strange clearances given in peculiar accents over obsolete radios, and nonprecision circling approaches in rain and crosswinds to some of the darkest airports you would wish never to encounter. I didn't pretend to welcome all of these conditions, but they were definitely stimulating, and there was the satisfaction of employing seldom used skills. What I hadn't foreseen, however, was the incompatibility of this type of work with the practical requirements of a more deliberate type of photography.

The scheduling was often so erratic that it was virtually impossible to predict with any certainty where I would be from one day to the next. Maintenance and weather delays, last-minute changes in customer requirements, short-notice acquisition of new business, questionable management decisions — all of these conditions, and more, caused a nearly continual juggling of aircraft and crews. Seldom did I complete an itinerary as it had been originally scheduled. It was not uncommon for me to start out on a ten-day trip flying passengers over North Atlantic Tracks between Europe and the United States and then two weeks later find myself on the other side of the world hauling freight from New Delhi to Istanbul. On several occasions I remember waking from a deep jet lag-induced sleep in the middle of the night in a dark hotel room without any idea as to what day it was or even what hemisphere I was in. It soon became evident that the nature of charter operations was such that it had been naive of me to think that I could do even brief assignment work or could photograph with any degree of continuity while I was on the road. It also became evident that there were significant difficulties in pursuing similar work at home, because my availability could never be assured.

But there was an upside. Even if I couldn't take on assignments or put together a well developed photo essay, my situation was ideal for street shooting — there was value in the constant flow of new people and places, even if the results were somewhat disjointed.

Eventually, as my prints and transparencies accumulated, I began selling them through stock photo agencies. But, more important, it began to dawn on me that while it was initially job circumstances that had relegated me to street shooting, this whimsical form of photography was not entirely alien to my own natural inclinations. I was making some good pictures and enjoying it immensely.

Airline crews flying scheduled domestic routes rarely have any more than an overnight crew rest, but international charter operations can present a different story. We certainly had our share of minimal ground times and quick turnarounds, especially at resort destinations in Mexico and the Caribbean, where the airplane was often refueled, cleaned and loaded with outbound passengers, all within three hours or less. In those instances, we were typically headed back to Detroit or Minneapolis for a 15-hour layover. If it wasn't two o'clock in the morning, or we weren't too tired, or the temperature wasn't five below zero, a brief stroll outside the hotel was a possibility. But on the more common trips to Europe and the Far East, 24-hour and 36-hour ground times were the norm.

Sometimes, especially during the slower winter off-season, we would be rewarded with marvelous three- or four-day stops in places like Rome, Bombay, or Singapore. On those special occasions, while the other crew members shopped or lounged around the pool, I was usually off taking pictures. There were simply too many potentially great images waiting to be captured, and it wasn't going to happen if I wasn't out there trying. *Try* is the operative word here. Anyone who has done much street shooting knows that it is a lot like fishing. You have to love fishing for the fishing itself, because only once in a while do you encounter the big one. And then it is just as likely to get away.

As much as possible, I jockeyed for the more interesting itineraries and, by using guide books and maps to research my destination, could usually formulate a pretty good action plan to implement upon arrival. I frequently took advantage of public transportation. Whether it was the Paris Metro, a Hong Kong ferryboat, a Philippine jitney, or even a bicycle in Ouagadougou, Upper Volta, it was a wonderful way to observe people. If time permitted, I might even rent a car and spend a day meandering through the coastal villages of Mexico or exploring a "white" city near Málaga, Spain.

Our aircraft were designed with the capability to convert back and forth from passenger to cargo or livestock configurations, so off and on we carried a variety of animals. They included mainland pigs for Hawaii, New Zealand cows for Malaysia, and Australian thoroughbred racehorses for Hong Kong. The horses

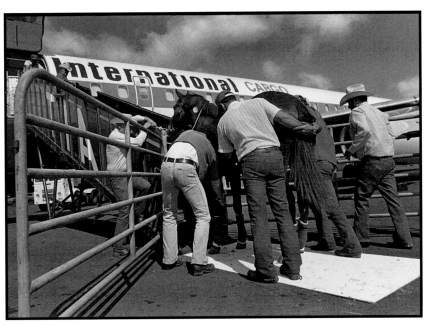

MAUI, 1978

13

could prove temperamental, even to the point of injuring themselves if we didn't provide smooth rolling takeoffs and gentle landings. On one occasion, I watched the reactions of people boarding our airplane after it had just been reconfigured for the busy summer tourist season following months of livestock operation. It wasn't long before I discretely retreated to the cockpit and allowed our flight attendants to explain the peculiar, lingering aroma.

But most of our passengers were of a two-legged variety and were no less remarkable. From quiet, apprehensive Vietnamese and Cambodian refugees coming to a new life in America to a planeload of wild party-going New Yorkers trying their best to have a bacchanalian orgy on their return from Club Med, there were all types. There was the woman en route from Shannon to New York

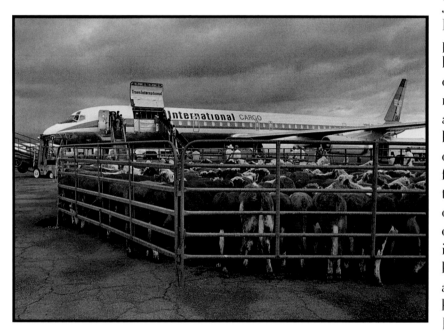

MAUI, 1978

who insisted on giving each of our seven flight attendants a $100 bill. She'd had a bit too much to drink, and when informed that crew members were not allowed to accept tips, she became quite vociferous and began moving about the cabin, tossing bills into the air. The seat belt sign and some "light turbulence" had no effect on her. Finally, at the request of our Senior Flight Attendant, I agreed to go back into the cabin and tell her in my most authoritative manner to sit down and behave herself. Naturally I assumed that once she realized who was speaking to her she would immediately comply. Instead, I encountered a feisty, somewhat wiry Irish woman of significant stature who began jabbing a

bony finger in my chest while "ordering" me to mind my own business and get back up front and fly the airplane. I complied. Don't look for her photograph in my book — I left that to the authorities who greeted her upon our arrival at Kennedy Airport.

Undoubtedly some of the more unusual flights were those connected with the Hadj, the annual pilgrimage to Mecca, which involved taking African Moslems to Jedda and back. Imagine elderly passengers from backwoods bush country who had never before seen an airplane up close and had to be given a quick course by the flight attendants on the use of simple conveniences; or the dedicated chef who insisted on cooking his own food in the aisle on a portable, homemade charcoal broiler; or the mysterious luggage that doubled in weight for its return flight to Africa — found filled with sand and holy water from Mecca. One of our DC-10 crews even had the experience of having a goat sacrificed for good luck on the ramp in front of their airplane.

I particularly liked roaming off the beaten path, often in Third World countries, searching for situations not usually recorded on film. When approaching people in these circumstances, it helps to know something of their customs and attitudes towards photographers. If people were basically friendly, I could often shoot first before they started posing; then wait and visit a while; then shoot some more after my novelty had worn off. But if the environment was

potentially hostile, it was best to advance with a nonthreatening smile and spend some time attempting to establish a positive atmosphere before trying to photograph. Common sense and a respectful, nonpatronizing attitude were appropriate. Knowledge of foreign languages is great, naturally, but even foreign language phrase books can be helpful. My *Say it in Swahili* pocket book never failed to break the ice.

Although street shooting is usually candid in nature, I've never relied on hiding in the shadows with a telephoto. Instead, I frequently enjoy interacting with my subjects and do so whenever practical. But if much time has passed since being out with a camera, I tend to be a bit hesitant and timid. Sometimes it takes a while to get the juices flowing, and it's necessary to force myself to jump in and get my feet wet and make something happen.

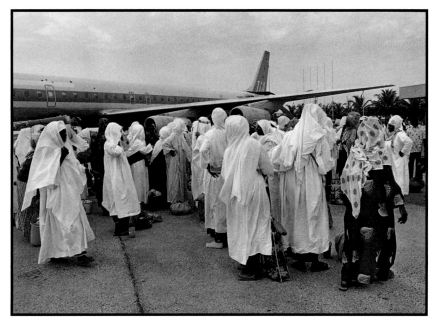

DAKAR, SENEGAL, 1975

Photographers can be notoriously apprehensive. Even the good ones. Not unlike pilots, they're always trying to anticipate what might go wrong. Even when operating in the relatively unpressurized conditions surrounding street shooting, they are not immune. There's the ever present fear of missing that once-in-a-lifetime shot for lack of a camera. In this respect I was less than conscientious, especially when not expecting any occasions for photography, and there were times I would want to kick myself for a lost opportunity.

Then there's the possibility of doing something really stupid, like forgetting to load film into the camera. I've done that. Or, for example, an incident that happened one day in New York City while I was eagerly clicking away at a typically delightful Times Square street happening. A man kept trying to get my attention. I told him to wait. Apparently he couldn't recognize the consummate photographer at work. When I had finally finished and asked him what he wanted, he asked, "Shouldn't your lens cap be off?"

I once heard the celebrated portrait photographer Arnold Newman say that his type of work was 90% rearranging furniture and 10% photography — my own experiences with environmental portraiture reveal this to be only a slight exaggeration. Similar percentages apply to street shooting, with chance replacing premeditation: 90% is the good fortune of having stumbled across a photo opportunity with a loaded camera, and 10% is the actual photography. The bottom line: Being in the right place at the right time is still the name of the game.

In that respect I was fortunate to have been able to move around the world with relative ease. However, one doesn't need to circle the globe to find interesting subject matter. Most of my early picture taking was close to home in Dover, Delaware, where I lived while still in the Air Force. Whether it was neighborhood children, a group of cooperative deer, or Amish farmers traveling the back roads in their horse-drawn buggies, there was plenty to photograph. The situation in the

San Francisco Bay Area, where I now reside, is certainly no less visually stimulating.

Street shooting can be a real adventure. But today, whether faraway or close to home, it requires increased diplomacy. In both developed and underdeveloped societies, photographers are not always held in high esteem. All sorts of sinister motives are attached to their picture taking. On rare occasions it may be possible to explain the subtle aesthetics of street photography and how the resulting images may emerge as a positive art form, but don't count on it.

Over the years I've had some rather unpleasant encounters. I was once chased down an alley in Singapore by an old man with a hatchet who felt I had stolen his soul with my little black box. Another time I was forced to turn over a roll of partially exposed film to a Saudi Arabian minor official who claimed that I was taking "bad pictures" in the marketplace. He couldn't comprehend how ordinary people could be more photogenically intriguing than a new freeway. Airport guards wanted me jailed for photographing a long, winding column of Mecca-bound Hadji pilgrims waiting to board my own plane at Kano, Nigeria. They reconsidered, after contemplating 255 stranded passengers and a large airplane cluttering up their ramp, but once again the film was confiscated. I remember one particularly nasty individual in the Big Apple who demanded money from me for taking his picture without permission. It took two of New York's finest to straighten him out. It's common knowledge among photojournalists that anyone is fair game on a city street, at least in the United States — the only restrictions relate to how the photographs are used. Nevertheless, it's still not a good idea to press the issue.

If this is beginning to sound somewhat negative, let me emphasize that these were isolated incidents, and that for each one of them there were hundreds of positive, enriching experiences. In fact, in some ways, meeting and learning about new people is almost as enjoyable as photography itself. Once, after photographing Nigerian schoolchildren at play during recess, I was invited to photograph in the classrooms and then stay for tea. I spent the better part of an afternoon discussing world events and our different cultures with the headmaster and some of his staff. And an event like this can happen anywhere.

Back in Delaware much of my time was occupied visiting a community of Mennonites. Although similar to the Amish in living a quiet and simple style of life, they were much more flexible when it came to picture taking. After some persuasion they graciously allowed me to enter into their lives and photograph them. We were from two different worlds. Yet we discovered that while on the surface our views of life and of the universe had little in common, we weren't so very different. Eventually we gained one another's respect and became friends.

Only occasionally would I give small amounts of money to take a photograph. Payment for photographs can quickly get out of hand, especially when there are lots of children in the vicinity. Before you know it, you're surrounded by a mass of humanity, and photography proves impossible. Sometimes I promised prints, which I either mailed or, if I returned to the community, delivered in person. Although this was usually not practical, whenever it did occur, it was always much appreciated by the subjects and personally satisfying to me. Some photographers carry a Polaroid camera so that they can present photos on the spot, but I never did that.

Sometimes I'm asked if a particular photograph was set up. At least in the realm of street shooting I've never deliberately set up a photograph. There have been times after missing a shot, however, when I've asked someone to repeat something. This doesn't bother me. Even the revelations exposing the staging of Doisneau's famous *Kiss by the Hôtel de Ville* can be overlooked, I believe, because it is such a great photograph.

Getting out of bed at 4 A.M. to photograph New York's Fulton Fish Market at sunrise and then continuing street shooting through the day until darkness fell over Central Park taught me to appreciate having a good pair of shoes on my feet and a minimum of equipment in my camera bag. I never carried artificial light on my trips and only rarely missed it. "Auto-everything"

cameras and the better zooms were not on the market when I was doing most of my traveling, but today they should be given serious consideration. They could lighten a photographer's load and probably even produce more usable images. Then again, some of the fun of street photography might disappear. Stalking prey with an auto-focus, auto-exposure, auto-bracketing, motor-driven state-of-the-art piece of photographic wonderwork would be similar to hunting squirrels with an AK-47. There is still something magical about working with a single Leica range finder equipped only with a 35 or 50mm lens. (In aviation we could compare the fun of piloting an open cockpit biplane to that of piloting a Boeing 747.)

Just as doctors are sometimes asked by friends and neighbors to diagnose their latest afflictions, and airline pilots are often asked about aeronautical happenings, photographers are frequently queried about equipment and technique.

Concerning aviation, most pilots do love to tell their stories when a suitable opportunity presents itself. But suffice it to say that whenever experienced, well trained crews are matched with properly maintained, modern airliners, air travel is a remarkably safe and efficient way to get from point A to point B.

Concerning photography, I usually traveled with two camera bodies and three lenses — one wide-angle, one normal for speed, and the third, a short telephoto.

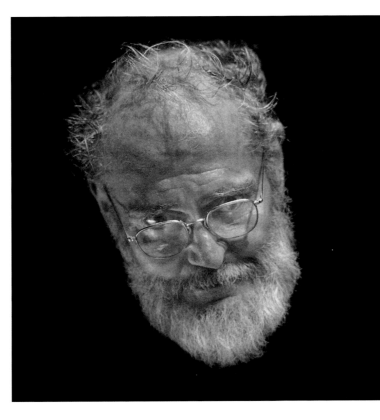

W. EUGENE SMITH, 1976 by Hap Stewart

Depending on the phase of the moon or other nebulous considerations, the cameras were either two Canon SLRs or a Leica M4 range finder and a small Rollei 35. Although the latest SLR systems are more versatile, both types of camera are fine for street shooting. I confess to being mildly addicted to well-made tools of the trade, but I try not to let this interfere with my picture taking. When all is said and done, it's not what's in your camera bag, it's what's inside your head that counts.

For the pictures in this book I used mostly Kodak Plus-X and Tri-X film. For black and white photographs, exposing the film is only the first step in the creative process. Then comes the darkroom work, where the image is brought to life, where the final product is fashioned. Depending on the quality of the negative, the darkroom experience can be either a relatively simple or an agonizingly time-consuming process. Even the most nearly perfect negative can require extra work to yield the best results. Conversely, even the nearly impossible negative will sometimes give up a fairly decent print — if you're willing to fight for it. On the wall of my darkroom there's a photograph I printed of the legendary photo essayist W. Eugene Smith, who was renowned for his marathon printing sessions. His eyes look sternly down at me over the top of his wire-rimmed glasses, and sometimes I can almost hear him say, "Don't give up now! You've almost got it!"

Things change. Today it appears that street photography in some circles is a bit out of favor. Not long ago I heard it referred to disparagingly as "derivative photography." Naturally, there is ample justification for constant experimentation and for blazing new horizons, but I see no reason to abandon something simply because it flourished fifty or sixty years earlier. After all, some of us still read books and go to the theater. If George Gershwin and Cole Porter were to reappear today, would we spurn their music? A constantly changing world with all its peculiarities offers a continuous flow of new things to register on film. A strong photograph can still elicit a corresponding emotional response.

My flying gave me the opportunity to witness much of the world through the viewfinder of a camera, and what I saw was not always nice. Both Mother Nature and human nature can generate much grief. But somewhere along the way I noticed that, instead of focusing on the darker side, I preferred recording the lighter side of life. At the risk of sounding too philosophical, I believe that street shooting has a role to play if for no other reason than it can sometimes provide a modicum of balance by provoking an occasional smile.

These photographs are the result of fleeting instants when photographer and subject just happen to cross paths. You might say they celebrate life through the visual experience.

Ground Time

RIJKSMUSEUM, AMSTERDAM, 1977

He sat transfixed in front of Rembrandt's painting in a large, quiet gallery of

Amsterdam's Rijksmuseum. I had scarcely noticed him when I first passed by

en route to another room. When I returned some twenty minutes later, he was

still there in the same position. He hadn't moved an inch.

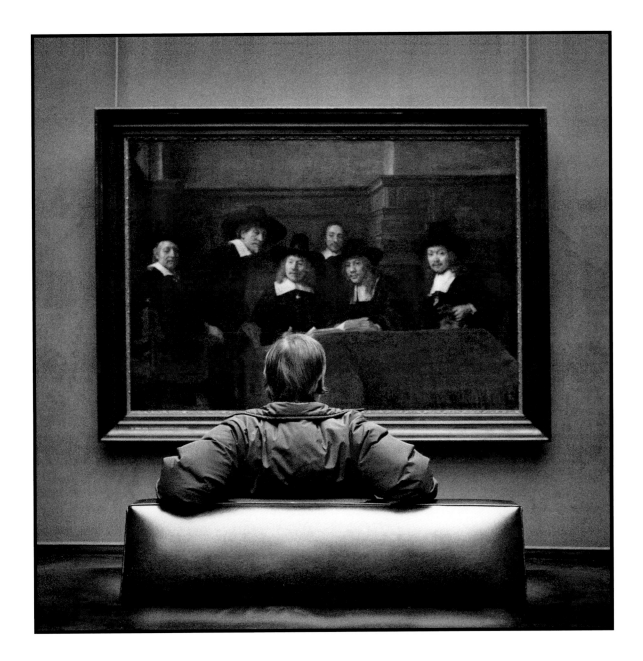

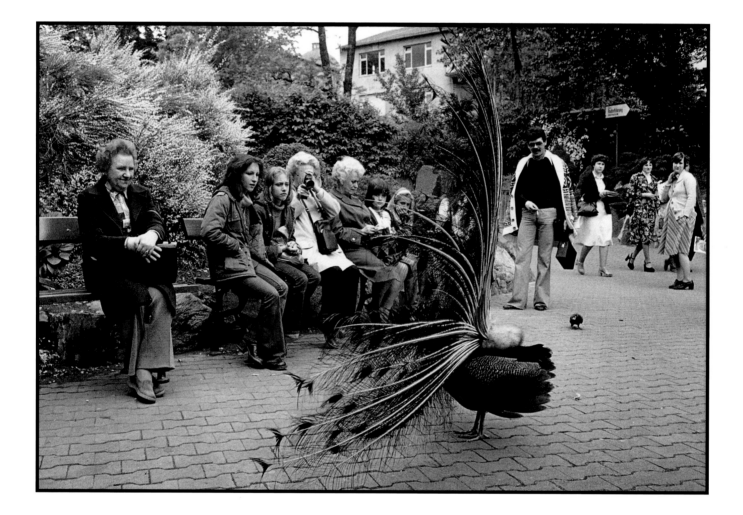

FRANKFURT, 1978

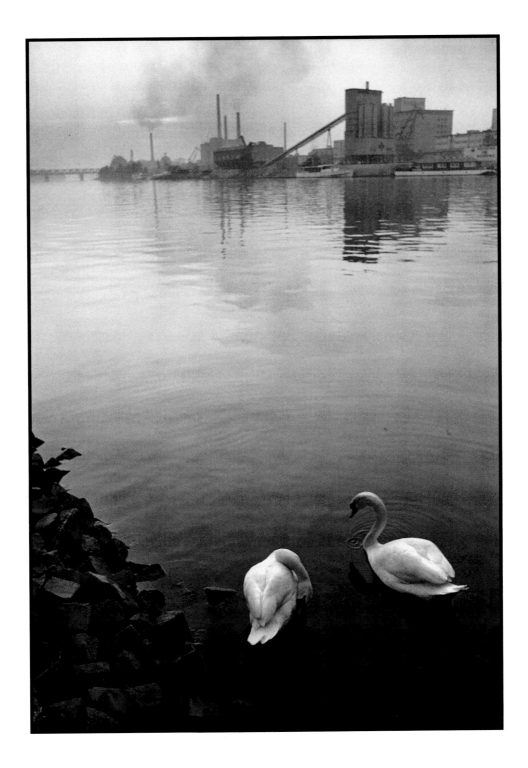

MAIN RIVER, FRANKFURT, 1976

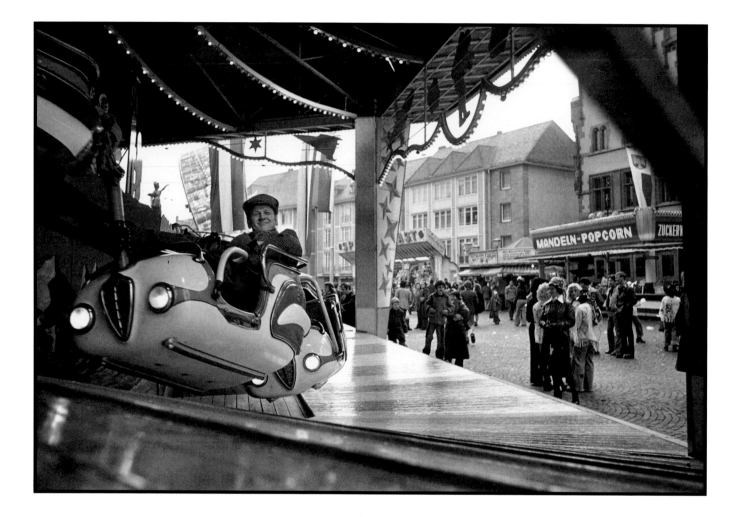

STREET FAIR, FRANKFURT, 1976

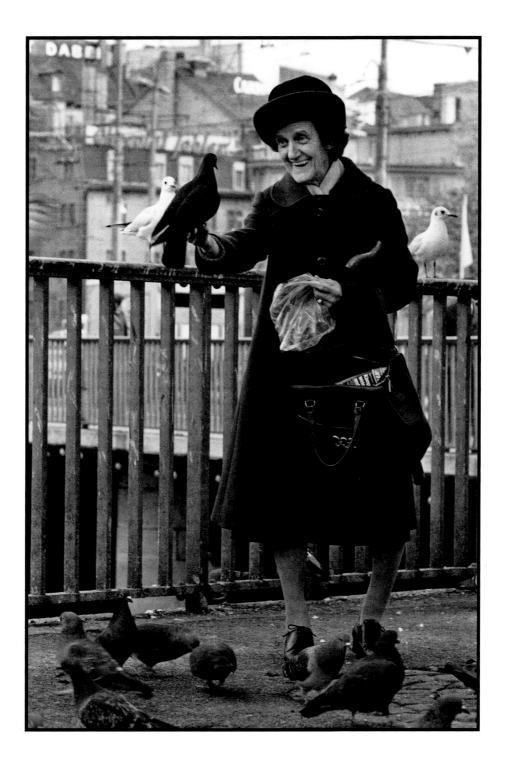

ZURICH, 1976

LIMERICK, IRELAND, 1975

Ireland's Shannon airport is a frequent refueling stop and crew change point for

aircraft flying between Europe and North America, and Limerick is the largest

city in the vicinity. The joys of investigating its pubs included stimulating

conversation and an occasional photograph.

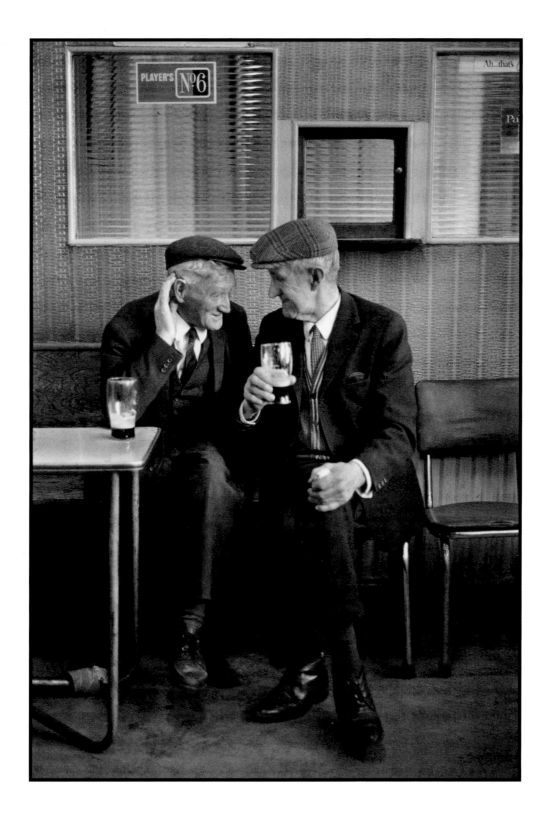

LOLLIPOP MAN, LIMERICK, IRELAND, 1978

The children called Patrick O'Connor a "lollipop man." He looked at me suspiciously and wanted to know why I would be wanting a photograph of him. I told him I thought it was wonderful that a man his age was still active in such an important activity. His frown deepened and he asked just how old I thought he might be. He looked at least 80. I suggested 75. A Leprechaun smile crossed his face and he informed me that in two months he would be celebrating his 90th birthday.

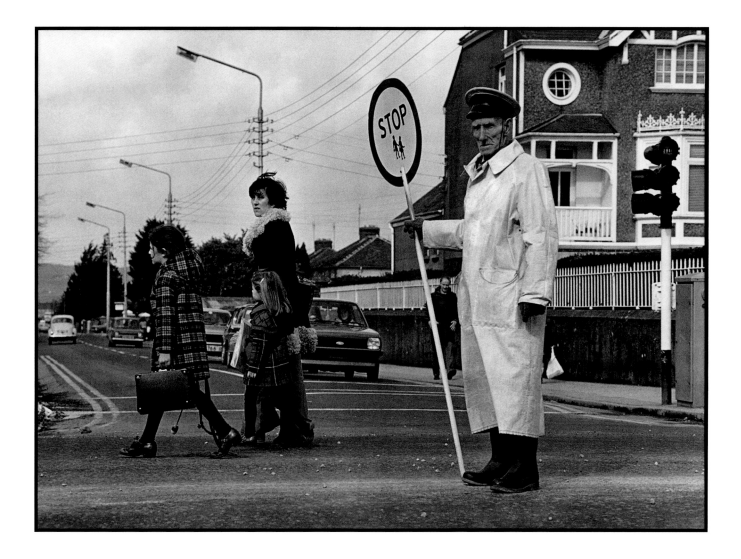

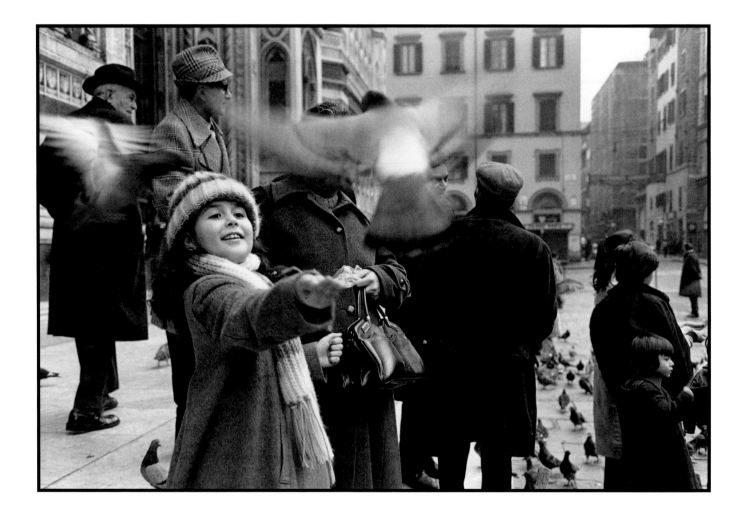

FLORENCE, 1978

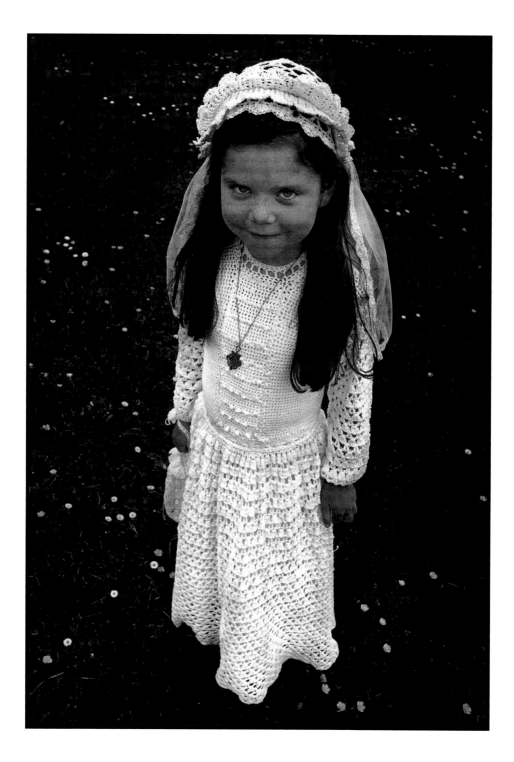

FIRST COMMUNION, LIMERICK, IRELAND, 1975

BOMBAY HOOK GAME REFUGE, DELAWARE, 1972

My 14-year-old son Jeffery spotted these deer in the distance as we were driving out of the game refuge. They were busy foraging and didn't notice me until I had approached within 30 yards. They looked up as one, I took their picture, and within ten seconds they disappeared into the tules.

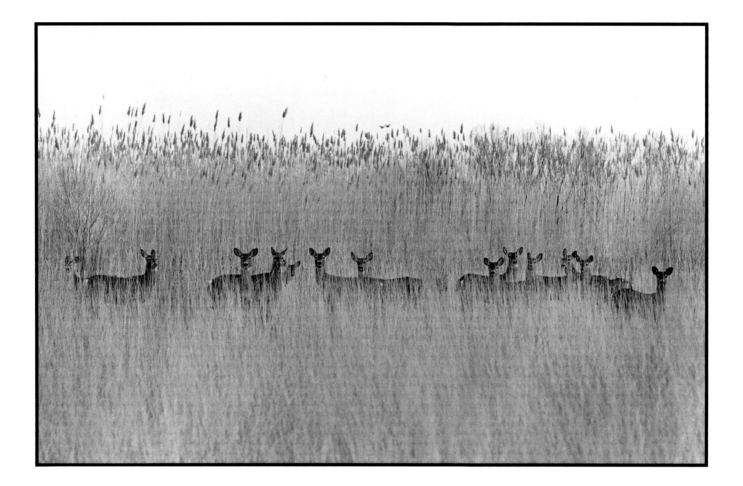

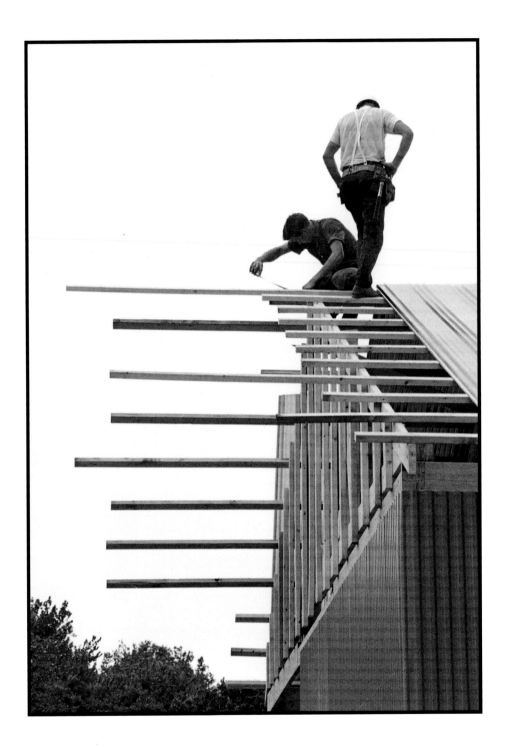

DELAWARE, 1973

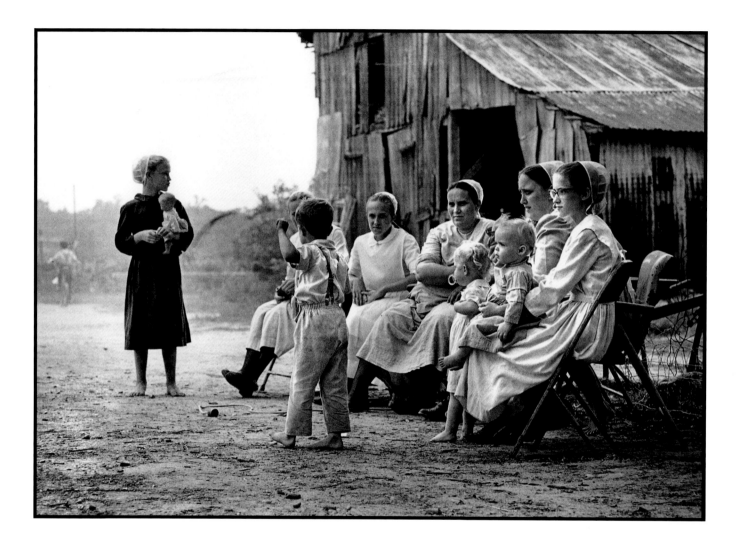

Relaxing after lunch while their
men were rebuilding a barn that
had been destroyed by fire.

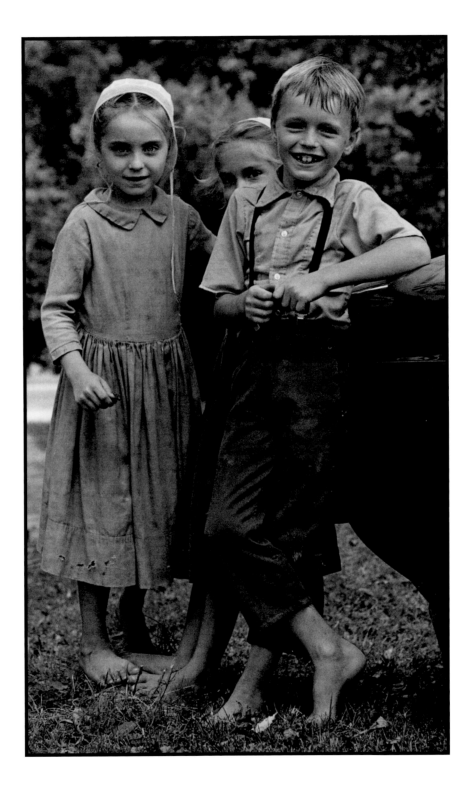

MENNONITES, DELAWARE, 1973

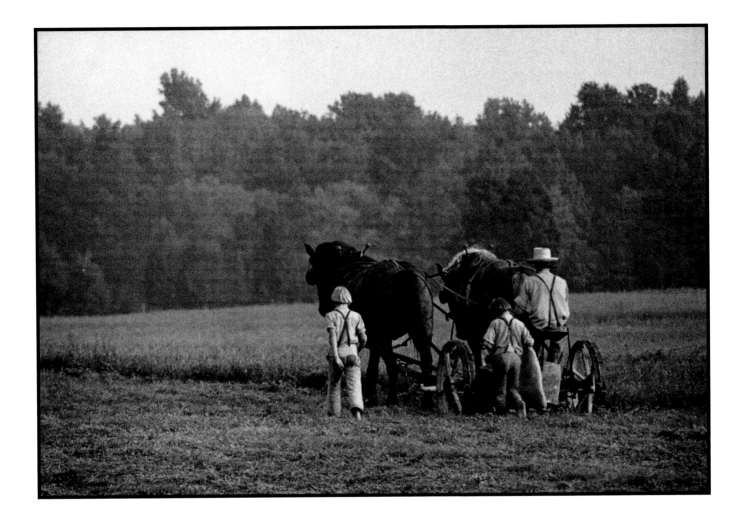

AMISH FARMER, DELAWARE, 1973

ANGELES, PHILIPPINES, 1971

This woman didn't want to be photographed because she didn't consider herself beautiful anymore. She had only one tooth left in her mouth. Finally, after much urging, she consented. When I returned a few months later to give her a print, I was told she had died.

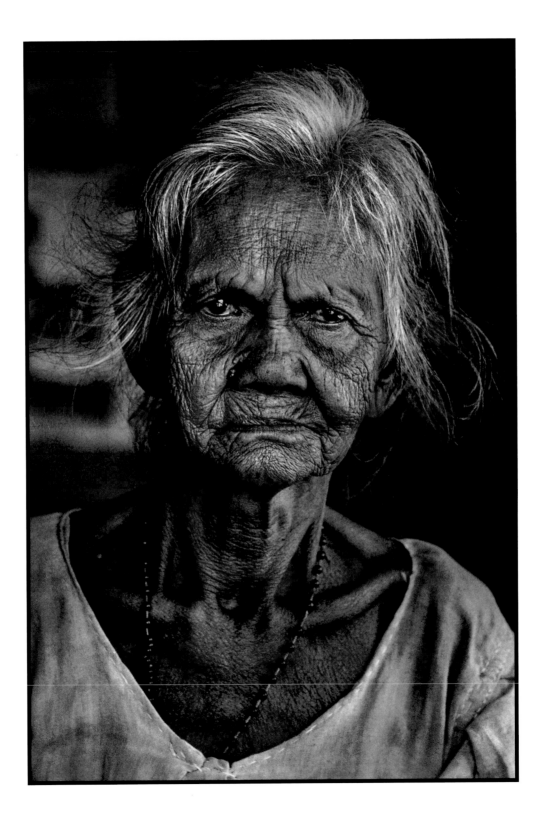

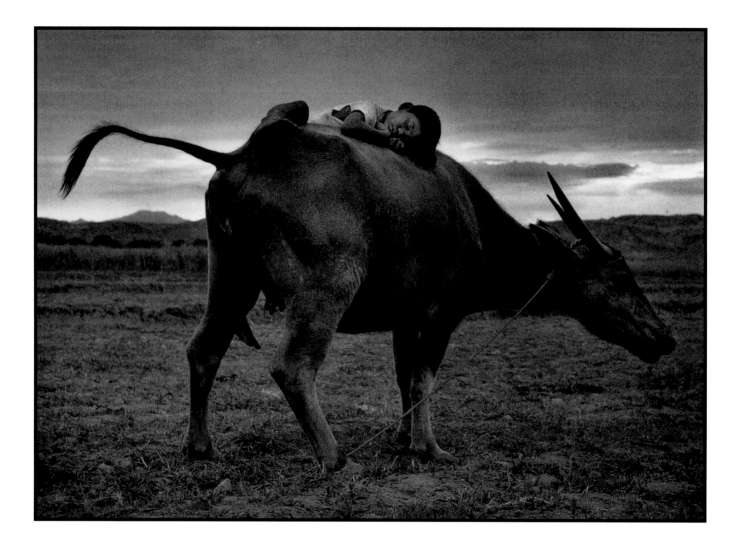

GUARD DUTY, PHILIPPINES, 1977

Carabao, or water buffalo, are
valuable family assets in Filipino
agriculture, and sometimes children
are assigned to watch over them.

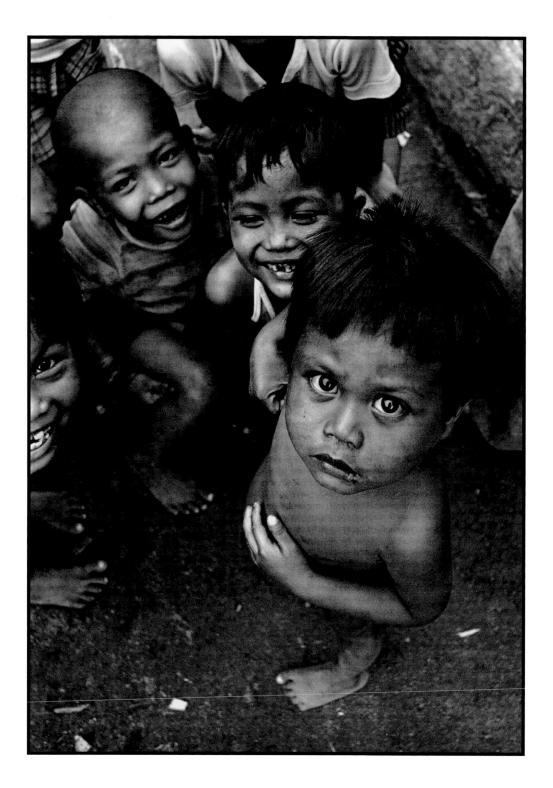

ANGELES, PHILIPPINES, 1976

NEGRITO PYGMY, PHILIPPINES, 1971

Standing at the window of his house, this proud man, barely four feet tall,

dressed in a highly prized, discarded flight suit, wasn't in the least

intimidated by the camera. Many years ago, possibly even before the separation

from mainland Asia, the Philippines were inhabited solely by small,

dark-skinned, wooly-haired pygmies. When the Spanish came, they named

them Negritos and drove them into the hills, where many still live today.

Although generally quite peaceful, they can be fierce warriors when provoked,

using their blowguns, spears, and bows and arrows with great efficiency. Some

of them had become "civilized" and lived in a village adjacent to the dump just

outside the United States-operated Clark Air Base. I found them very warm and

friendly, always eager to share a bottle of San Miguel and a meal of roasted pig

or dog meat. Despite their squalid existence, these little people possessed all

the dignity of other more affluent and sophisticated human beings.

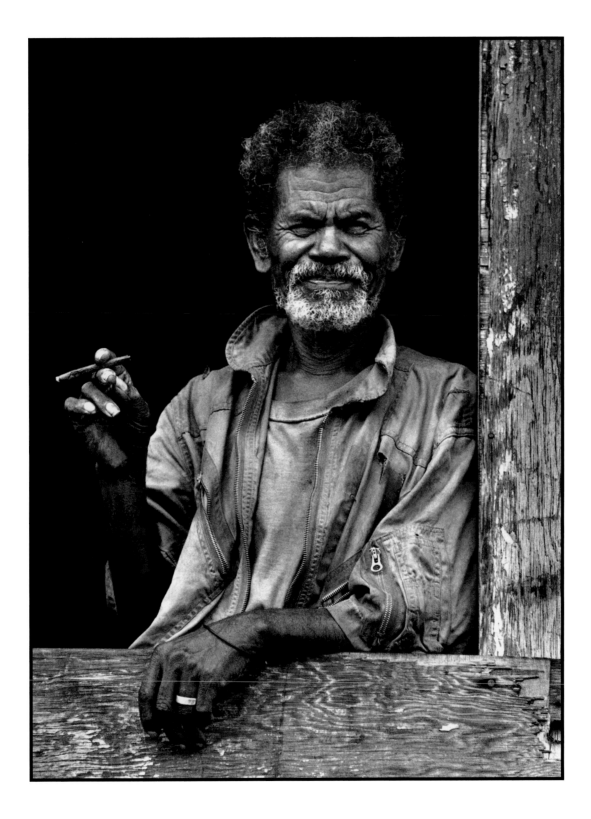

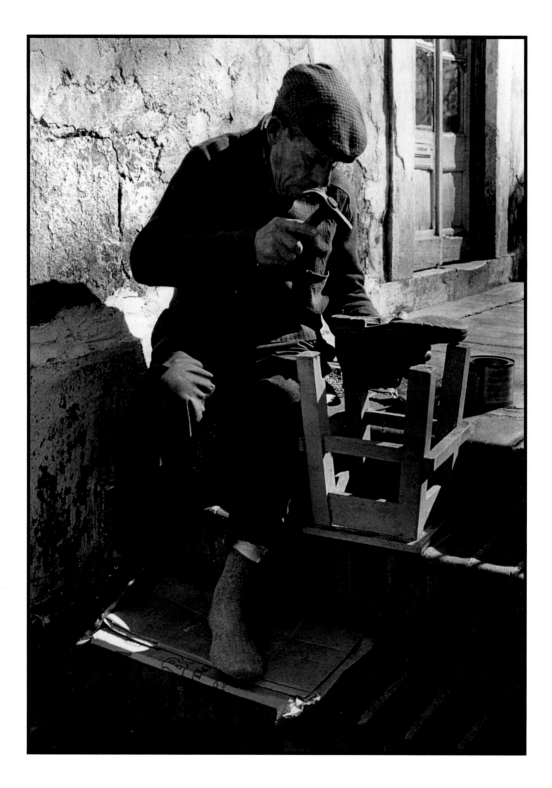

LISBON, 1979

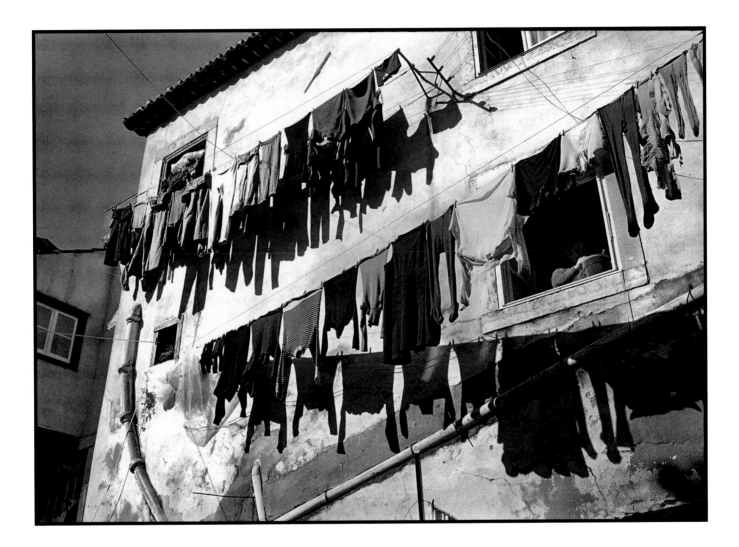

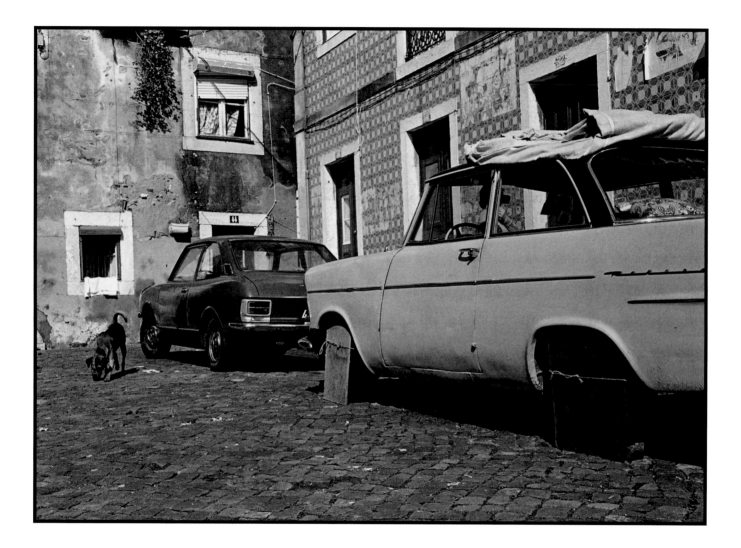

LISBON, 1979

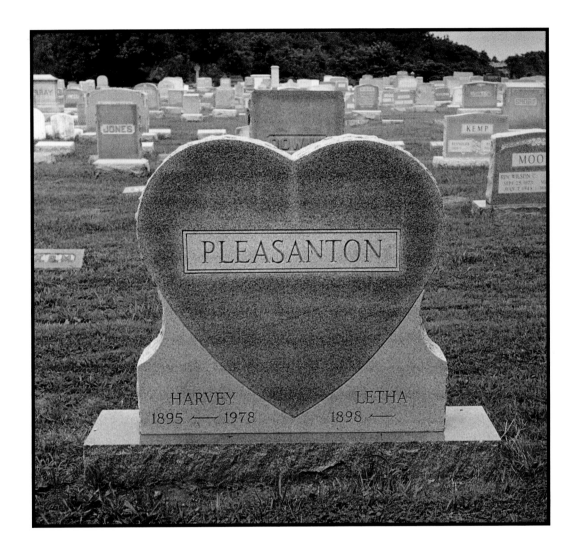

47

GRASSHOPPER, NEW YORK CITY, 1973

Howard Chapnick of the Black Star Photo Agency once questioned if the

grasshopper peering down on Manhattan from atop the Empire State Building

was real, or if I had put it there. It was, and I hadn't.

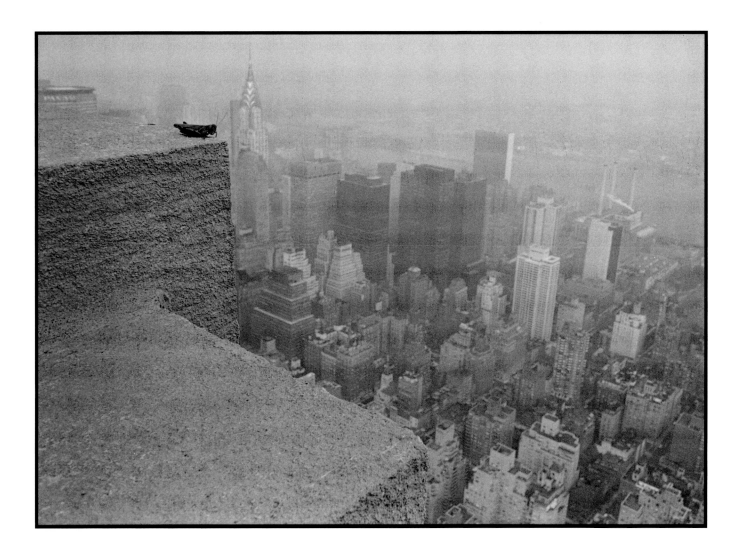

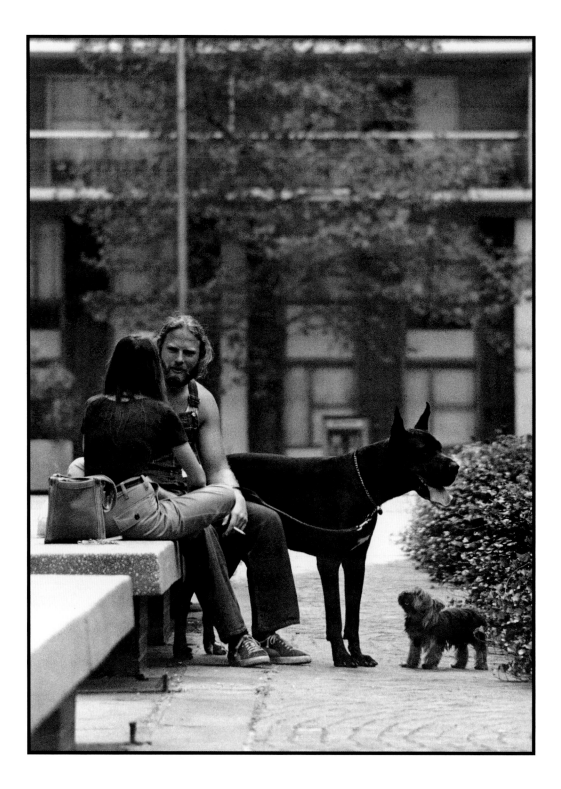

GREENWICH VILLAGE, NEW YORK CITY, 1973

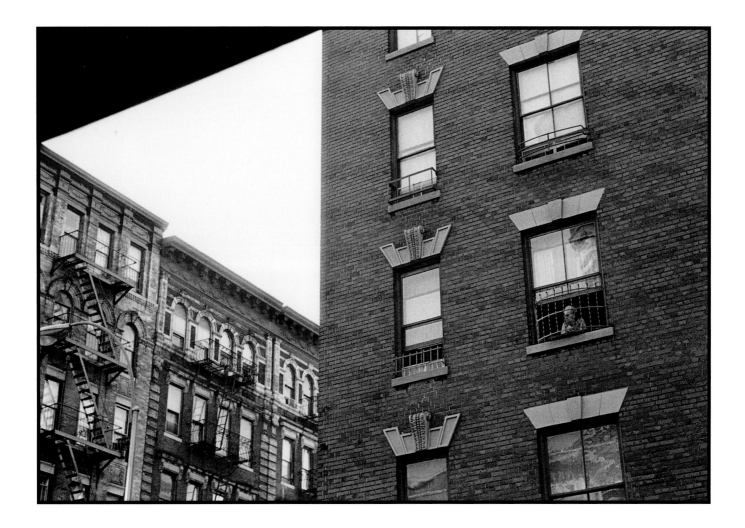

NEW YORK CITY, 1983

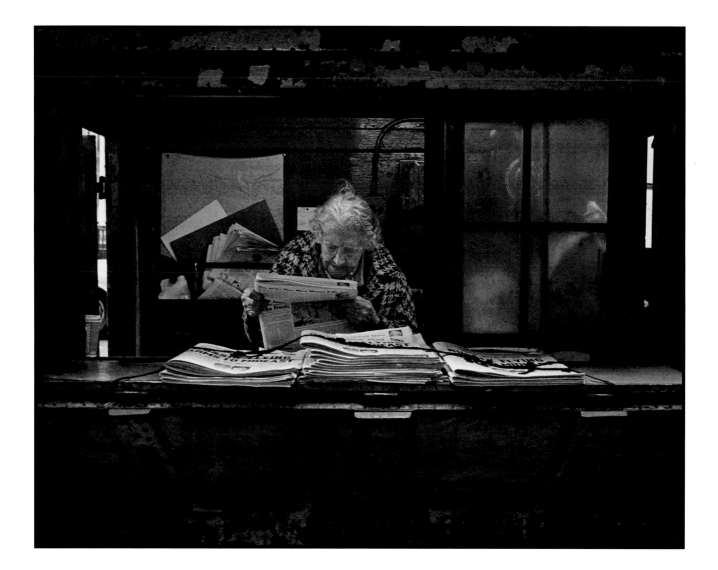

NEW YORK CITY, 1973

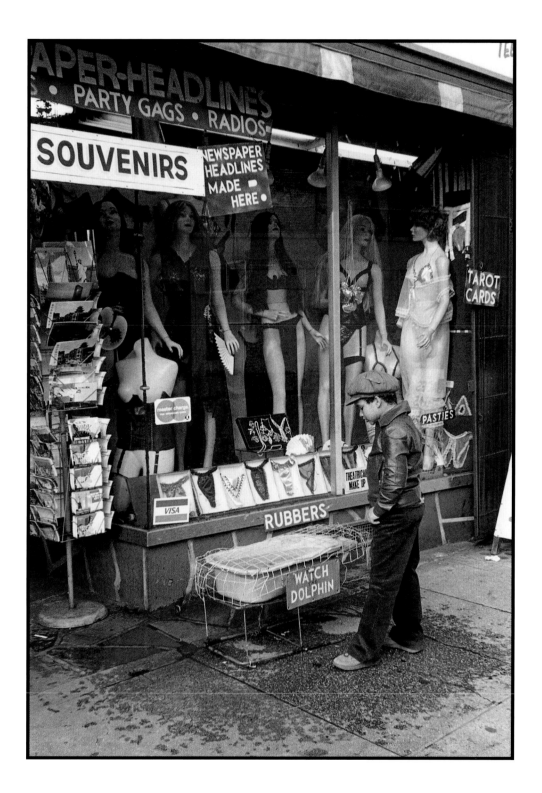

TIMES SQUARE, NEW YORK CITY, 1978

EN ROUTE TO MECCA, 1975

Every year, Moslems from all corners of the world converge on their holy city,

Mecca, making a pilgrimage, which they call the "Hadj." Some believers save

for a lifetime to achieve this goal at least once. For the most part, air travel to

nearby Jedda has replaced the camel and other forms of transportation for this

important journey. Needless to say, on these flights as on others, most of my

inflight time was spent in the cockpit, and only rarely did I venture back into

the cabin for the purpose of taking a picture. I noticed this young girl sitting in

the front row, and she was irresistible.

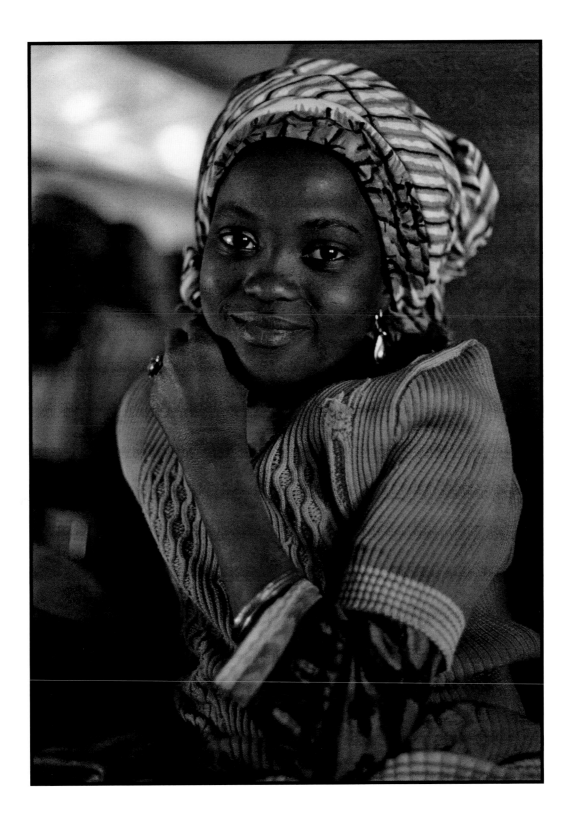

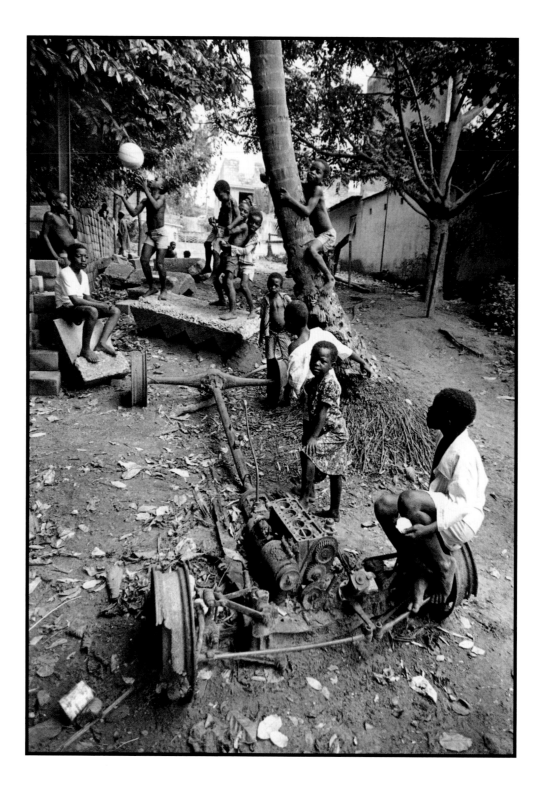

ABIDJAN, IVORY COAST, 1980

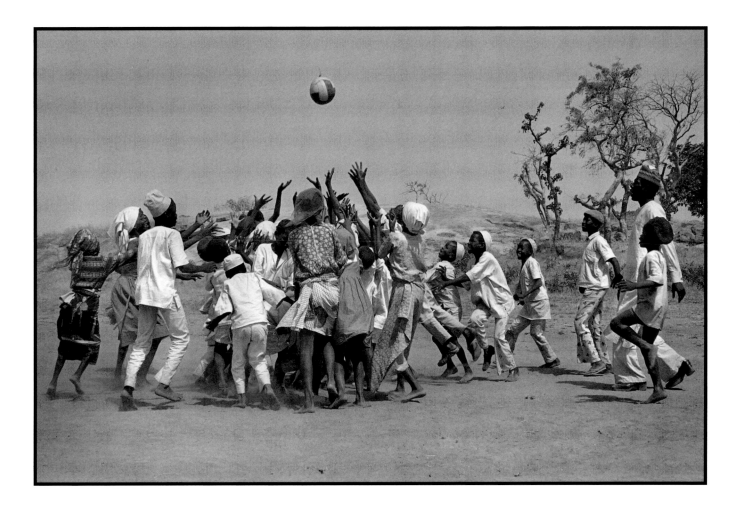

After photographing at a primary school several
miles outside of Kano, I was invited to join the
headmaster and some of his staff for afternoon
tea and a discussion of our two cultures.

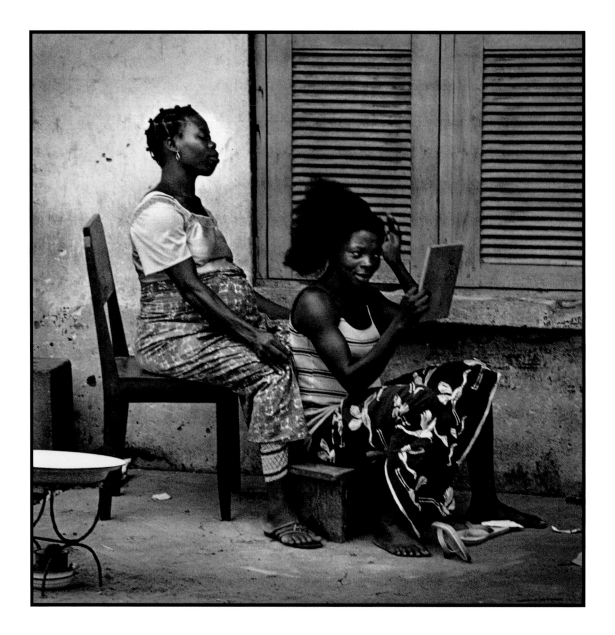

ABIDJAN, IVORY COAST, 1980

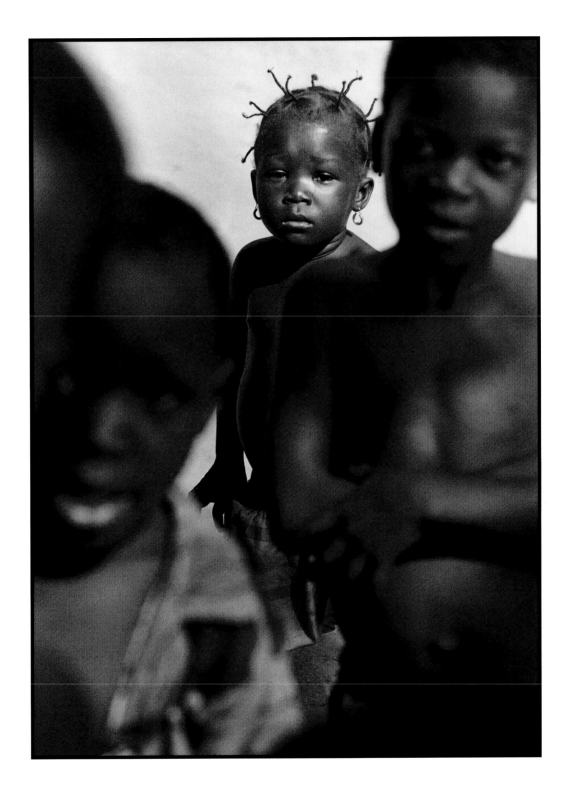

IVORY COAST, 1975

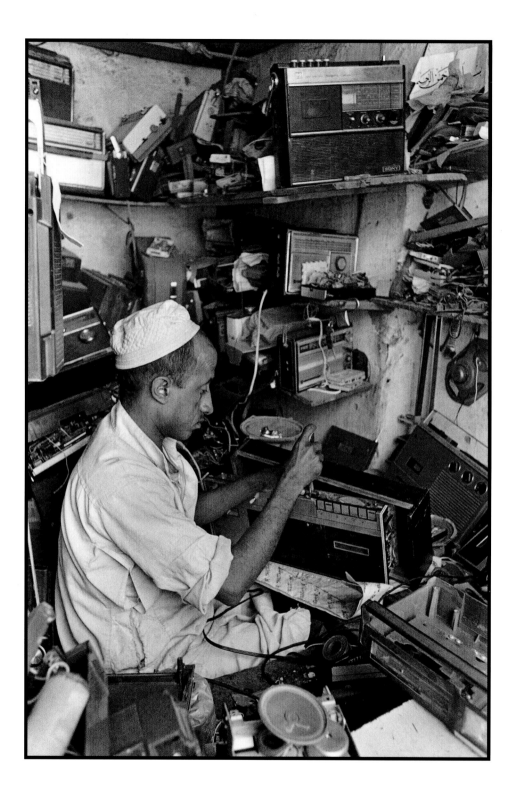

JEDDA, SAUDI ARABIA, 1975

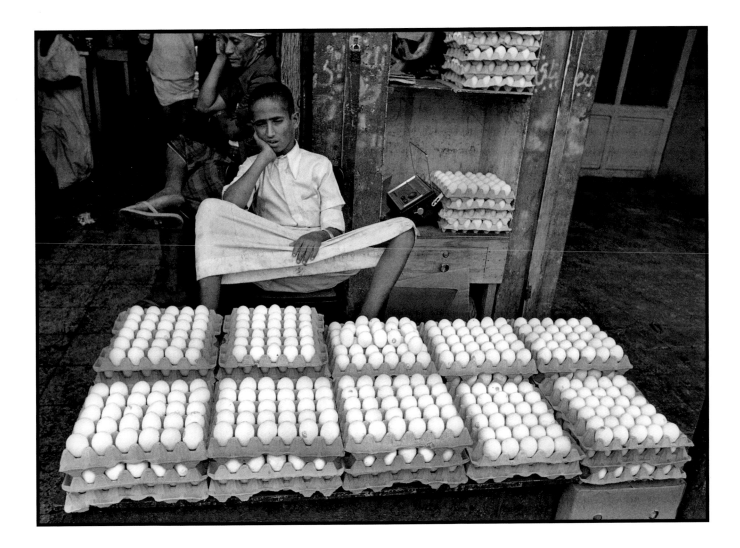

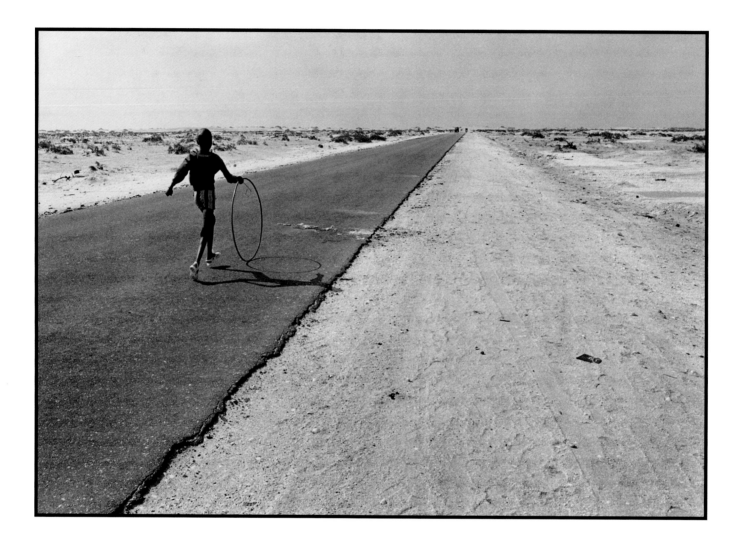

MAURITANIA, 1980

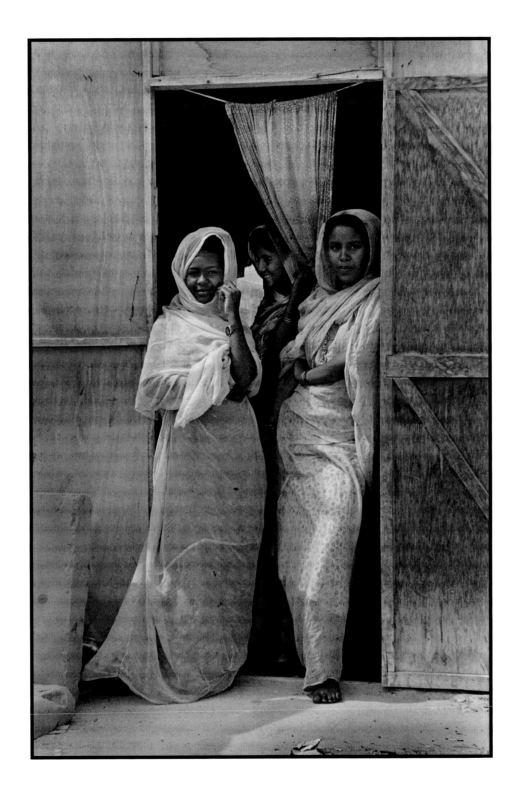

LADIES OF THE AFTERNOON, MAURITANIA, 1980

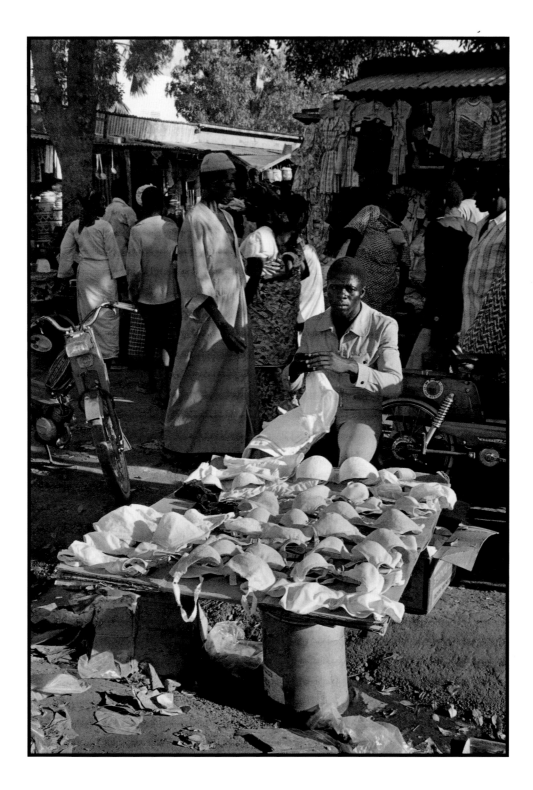

OUAGADOUGOU, UPPER VOLTA, 1980

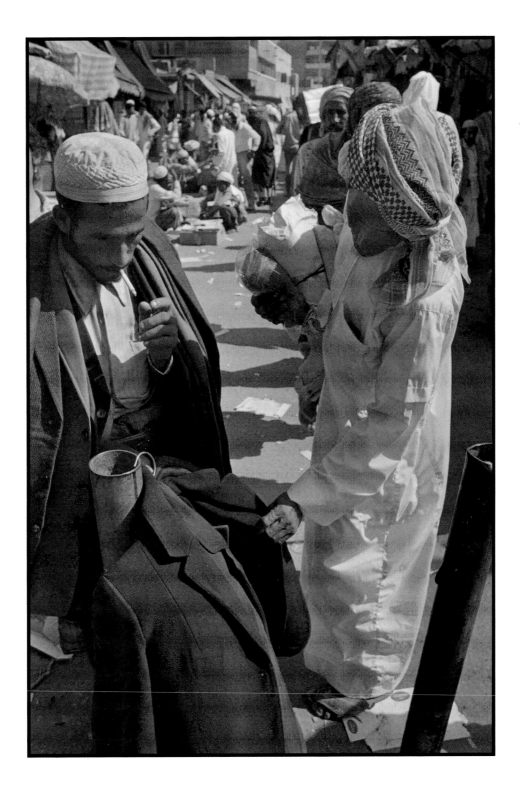

JEDDA, SAUDI ARABIA, 1975

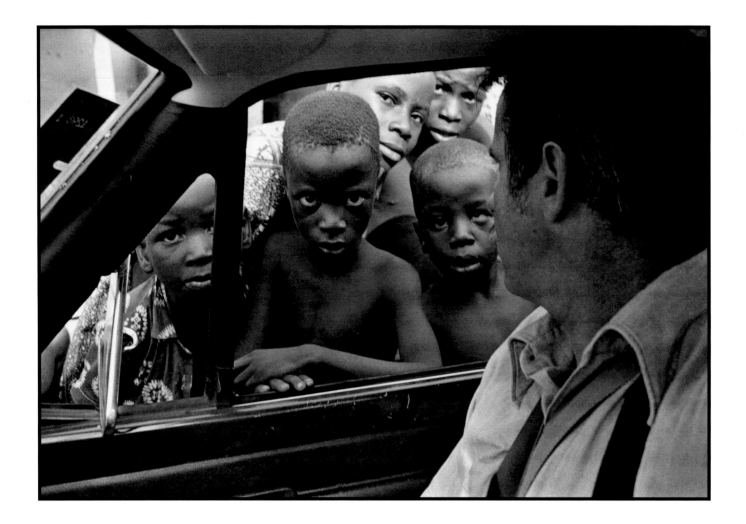

SELF-PORTRAIT WITH FRIENDS, DAKAR, SENEGAL, 1975

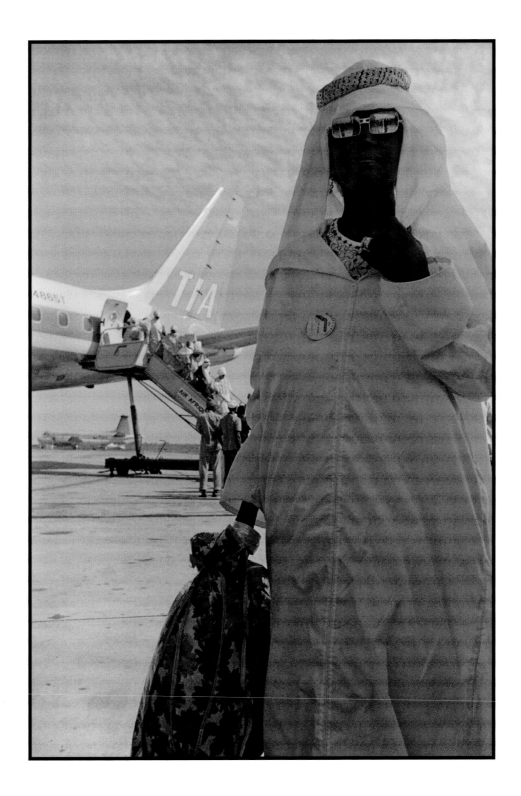

RETURN FROM MECCA, DAKAR, SENEGAL, 1975

TOLOX, SPAIN, 1977

Located only a short drive into the hills north of Málaga, Tolox is a contrast of

brilliant whites, blacks and shades of gray. Find a location, compose the frame,

and then wait for something to happen. During siesta it can be a long wait.

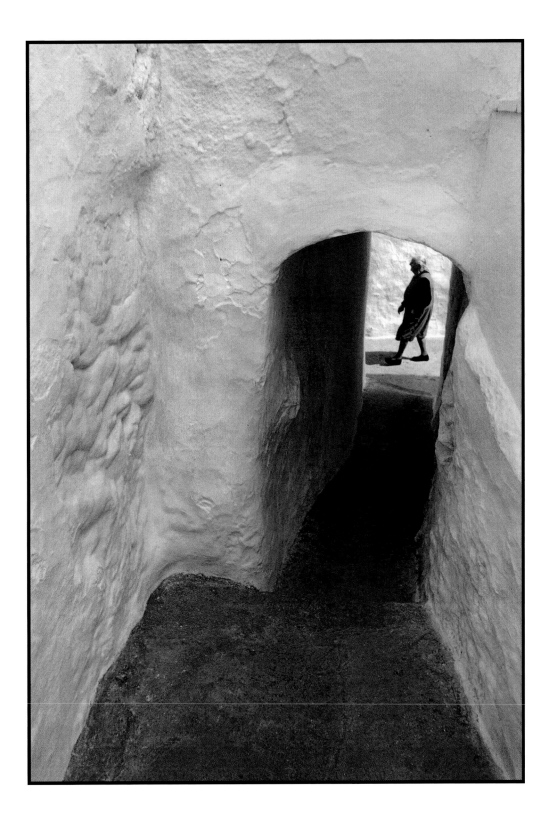

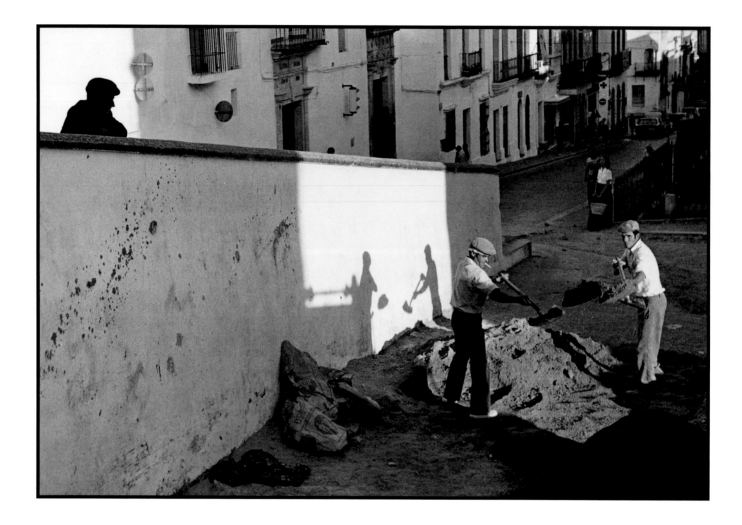

COSTA DEL SOL, SPAIN, 1977

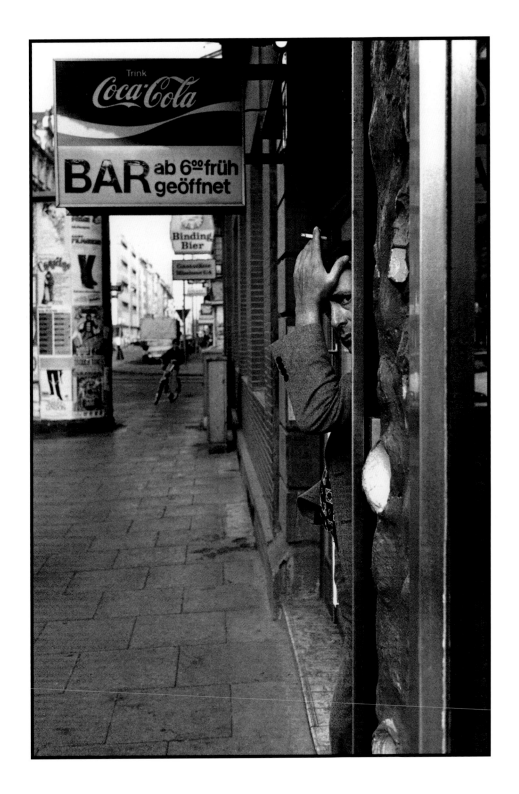

FRANKFURT, 1976

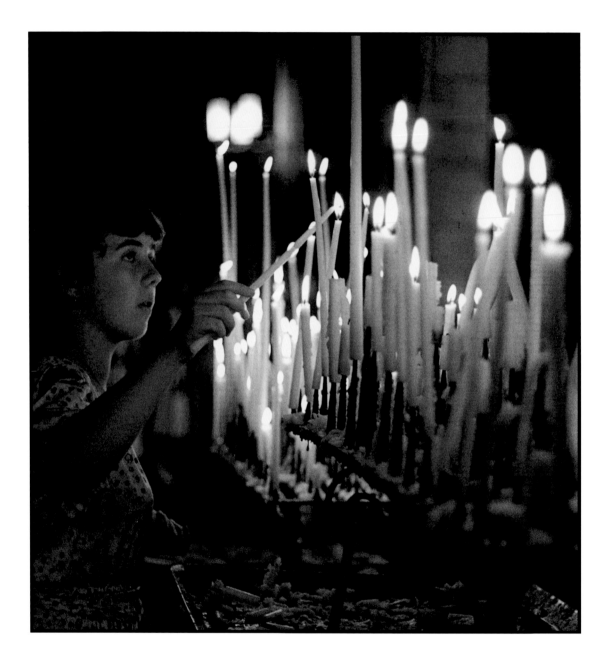

NOTRE DAME CATHEDRAL, PARIS, 1979

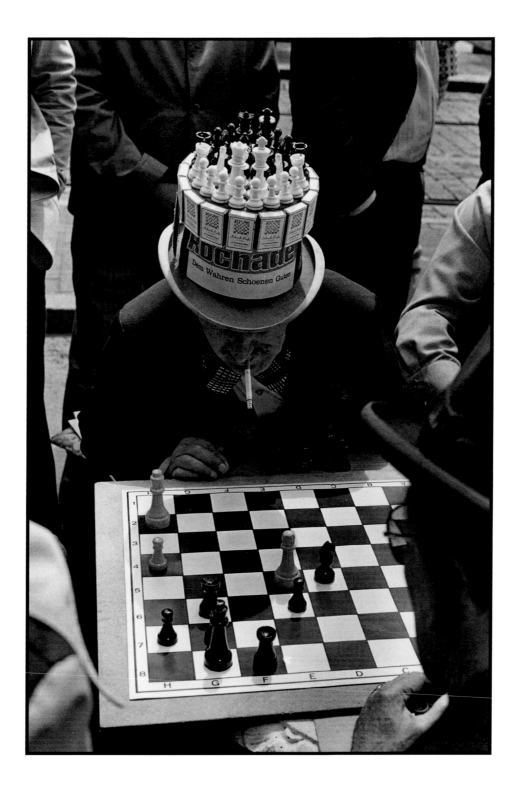

FRANKFURT, 1975

73

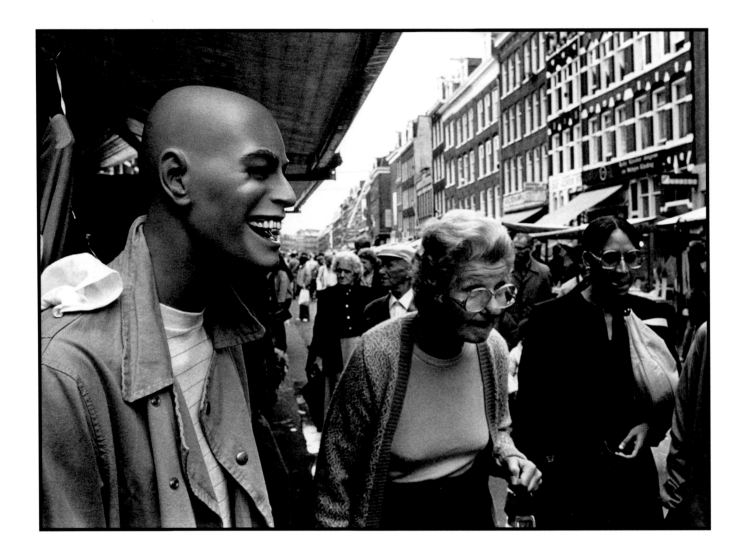

AMSTERDAM, 1982

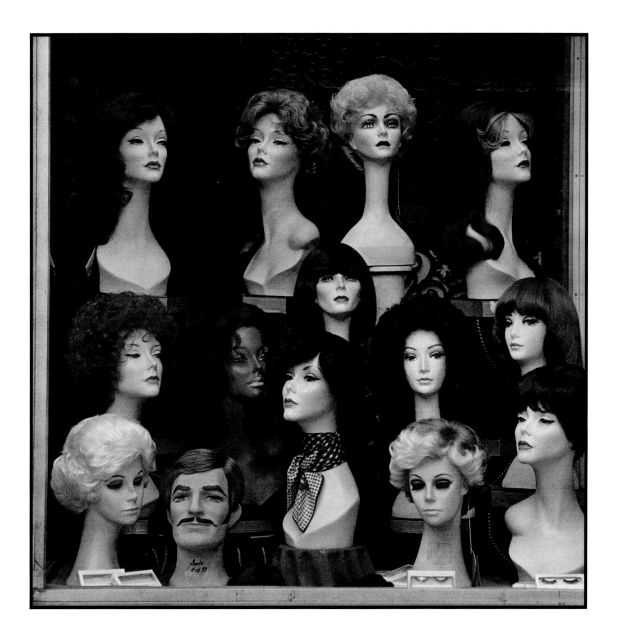

NEW YORK CITY, 1976

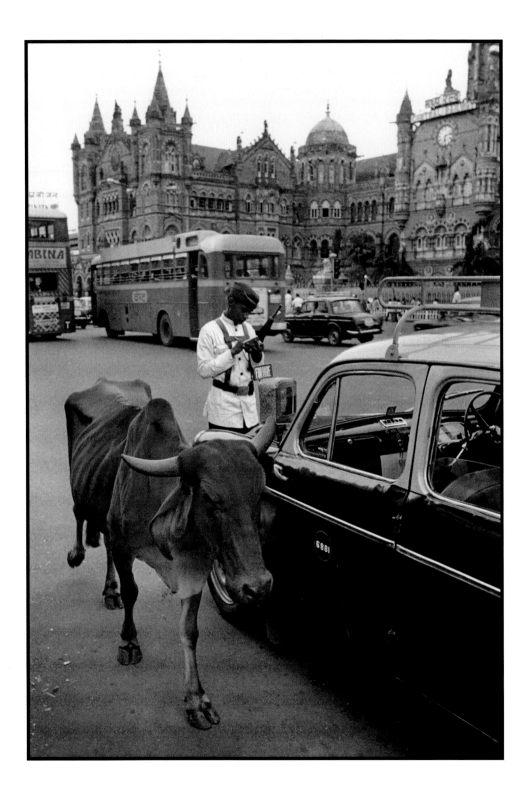

SACRED COW, BOMBAY, 1975

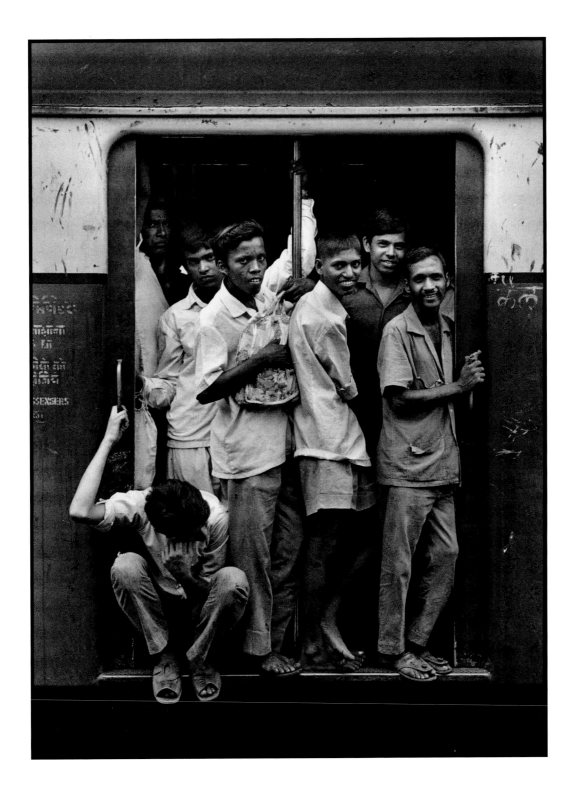

COMMUTER TRAIN, BOMBAY, 1975

POOLSIDE, DETROIT, 1978

In uniform, bags packed, and airport limo waiting, it took me less than a
minute to capture the ambiance of this winter wonderland.

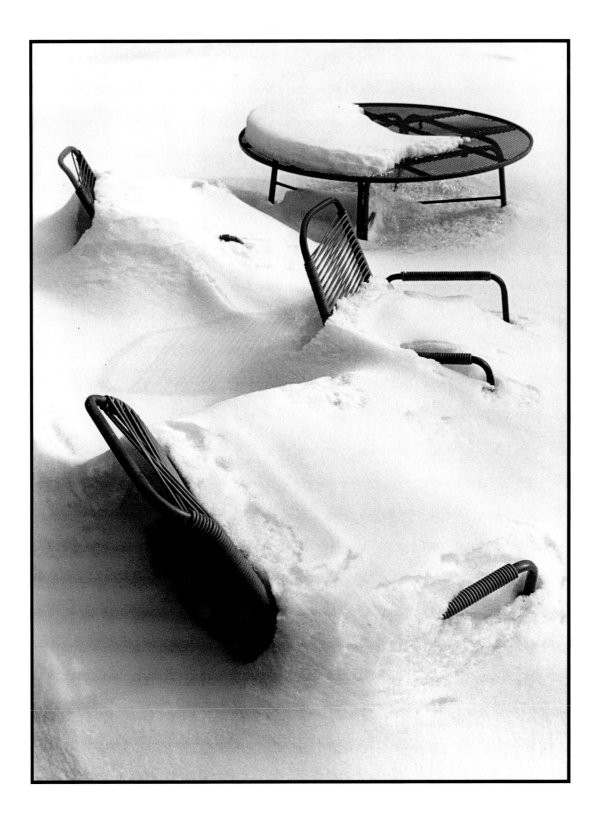

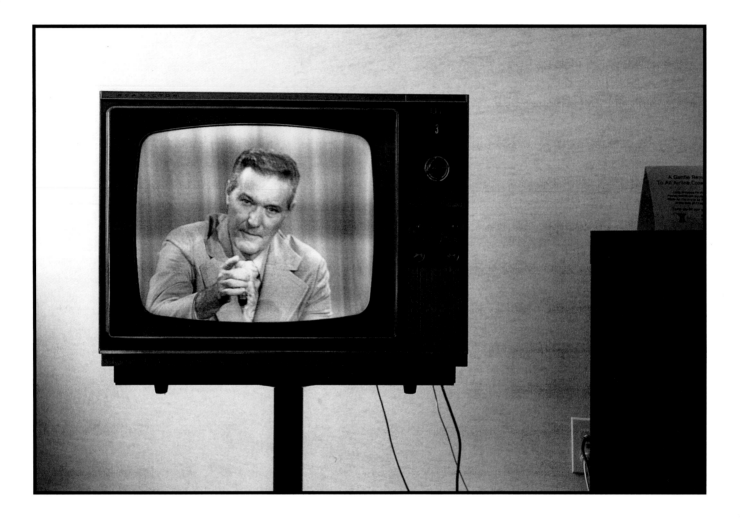

TV PREACHER, CHARLESTON, SOUTH CAROLINA, 1977

A rainy Sunday morning at an isolated hotel.

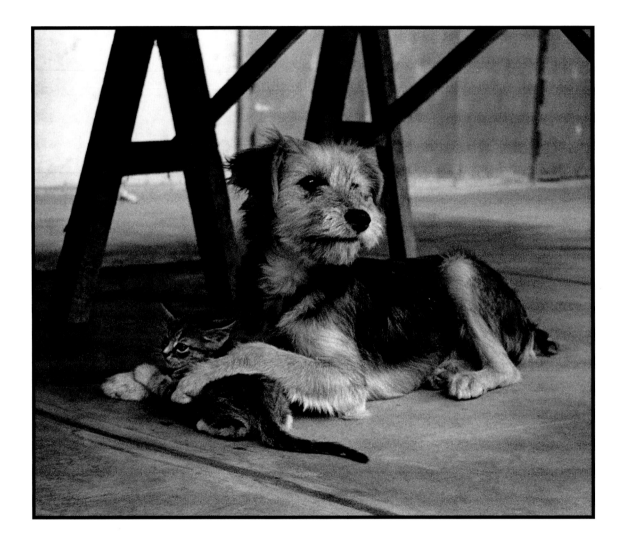

PEACEFUL COEXISTENCE, LIMA, PERU, 1977

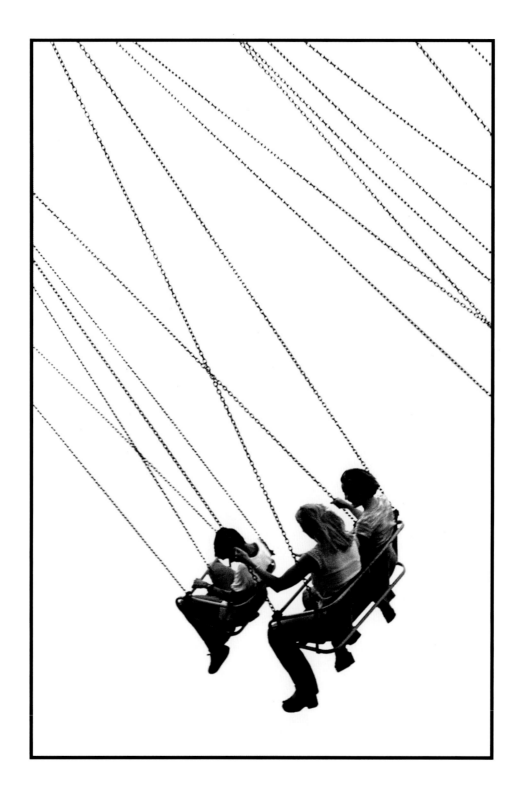

AIRBORNE FLIGHT ATTENDANTS, HOUSTON, 1976

LIMERICK, IRELAND, 1975

Bridget Murphy was a stranger who came up to me on the street and insisted

that I visit her church and photograph the "exquisitely carved statue of the

Blessed Virgin." Later, we repaired to her favorite pub, where I heard the story

of her life. She was 75 and had worked as a domestic 40 years for the same

employer. She also played concertina, piano, and guitar at the Two Mile Inn

outside of town.

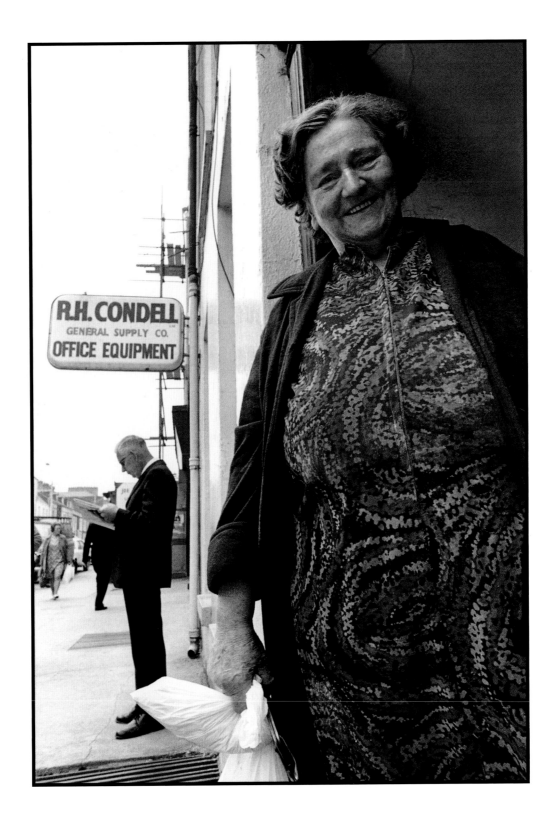

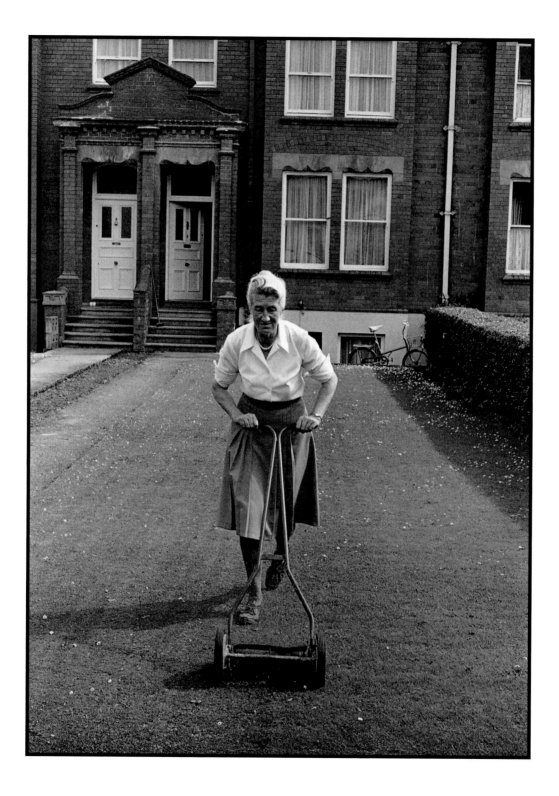

LIMERICK, IRELAND, 1979

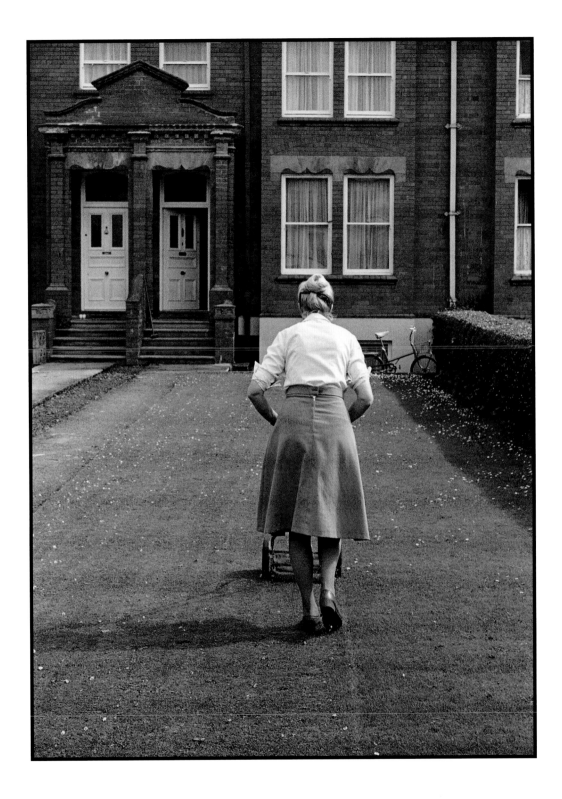

LIMERICK, IRELAND, 1979

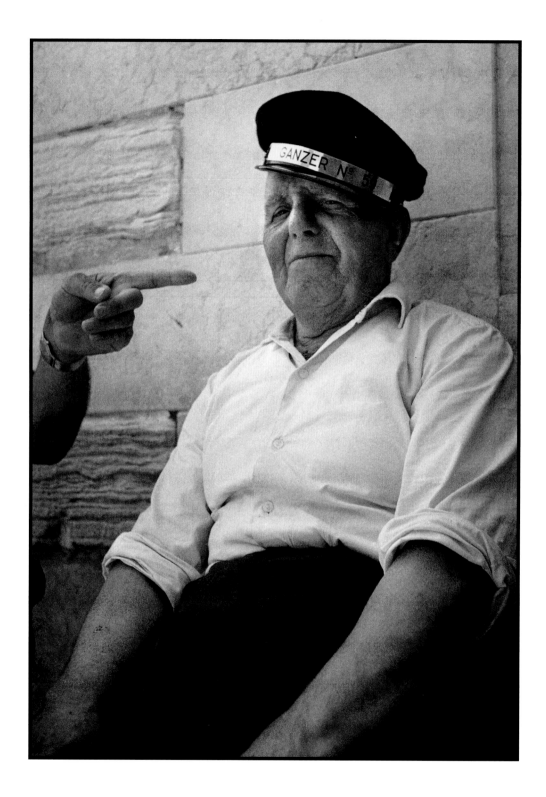

VENICE, ITALY, 1972

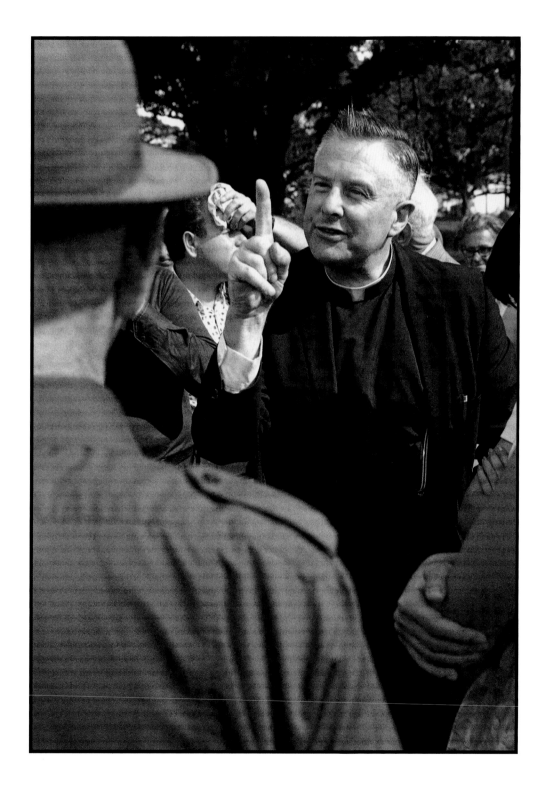

SPEAKERS PARK, SYDNEY, 1979

89

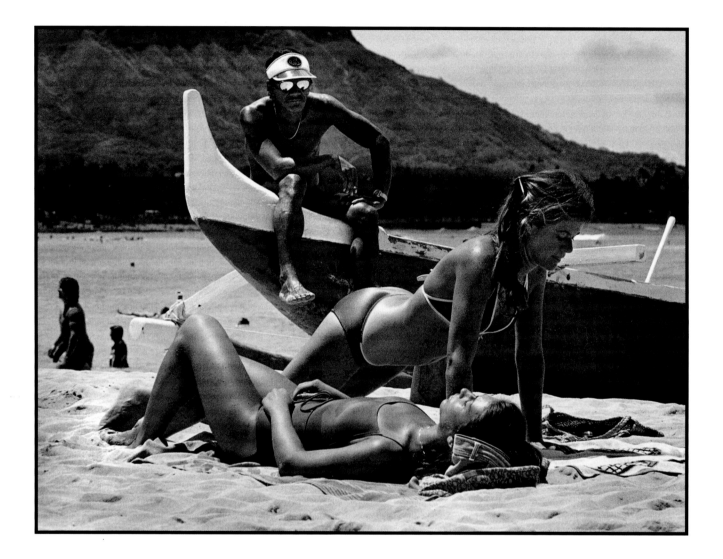

WAIKIKI BEACH, 1979

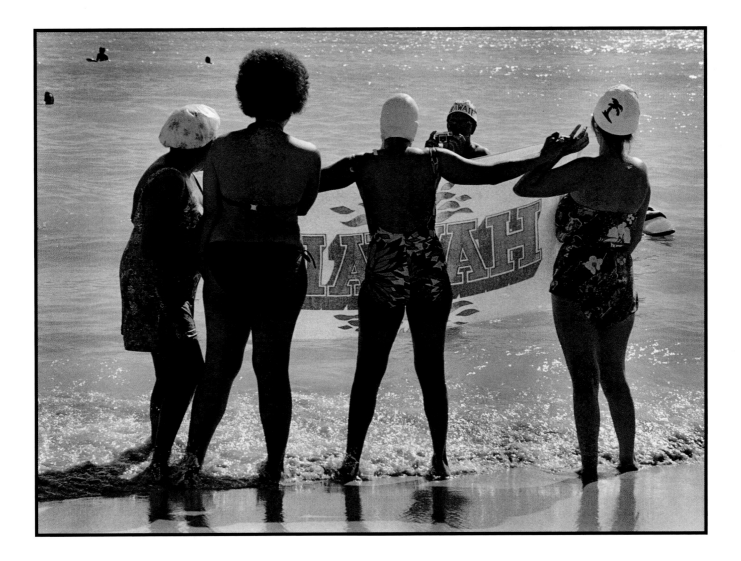

WAIKIKI BEACH, 1978

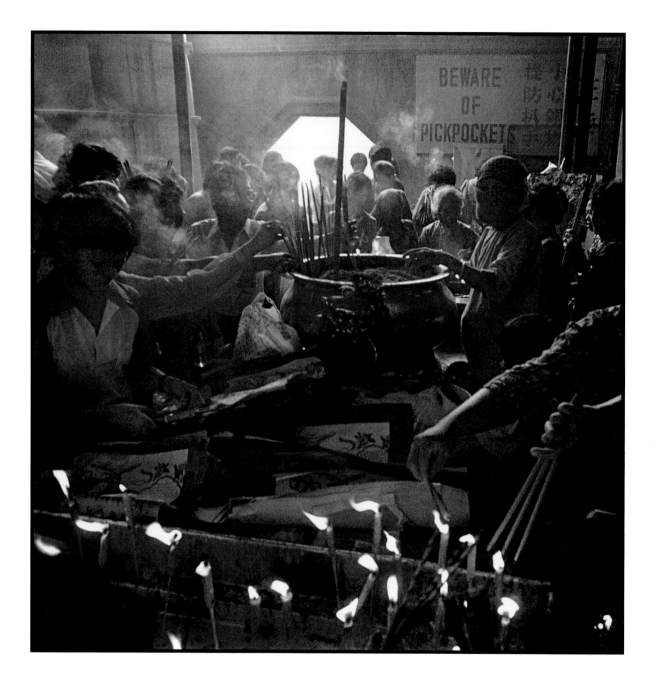

BUDDHIST TEMPLE, SINGAPORE, 1981

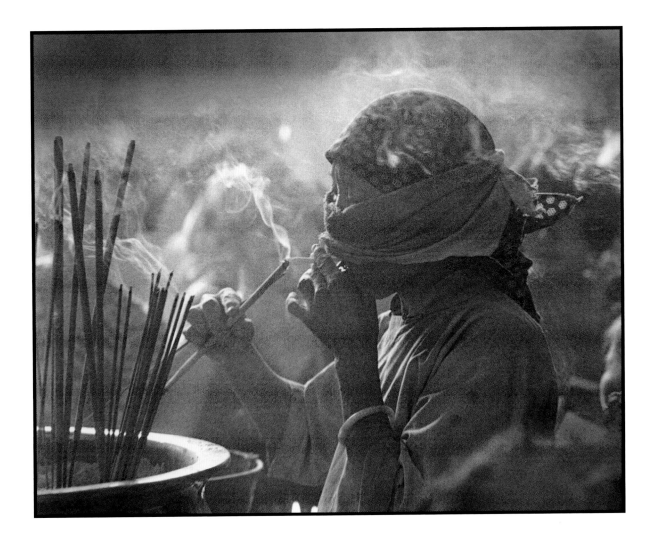

The smoke from incense during the celebration of
Chinese New Year was sometimes so thick that it
could be tolerated for only a few minutes at a time.

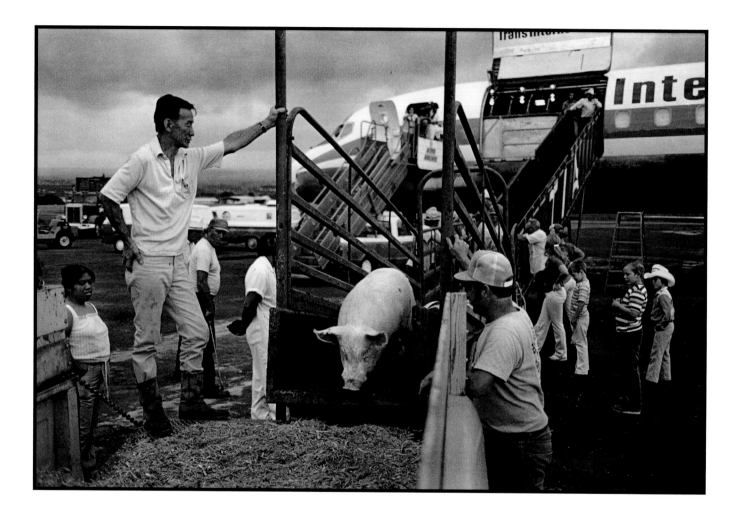

FLYING PIG, MAUI, 1978

Besides people and cargo, we also transported livestock,
such as thoroughbred racehorses, cattle, sheep, and pigs.

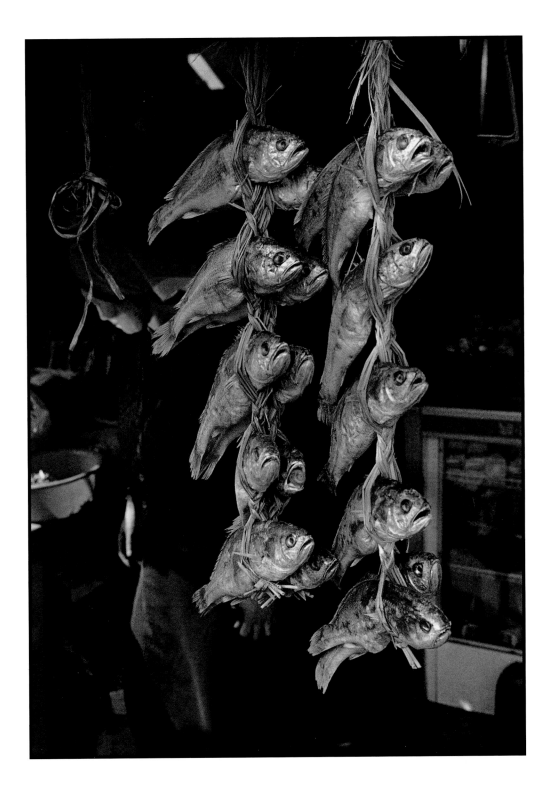

SEOUL FOOD, KOREA, 1979

PARADE REST, TOKYO, 1984

A formation of soldiers marched onto the grounds of the Meiji Shrine and lined up in front of the main building for what appeared to be the prelude to a religious service. A young Japanese woman fell in at the rear of the formation and assumed the parade rest position. She was quite serious.

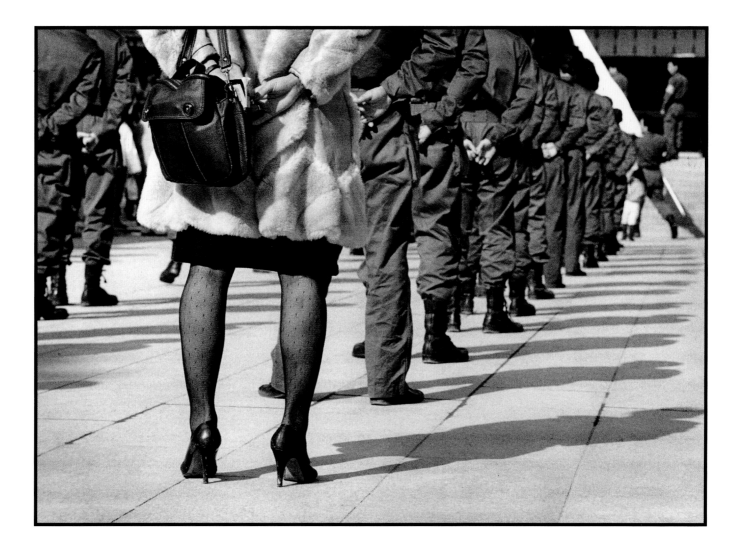

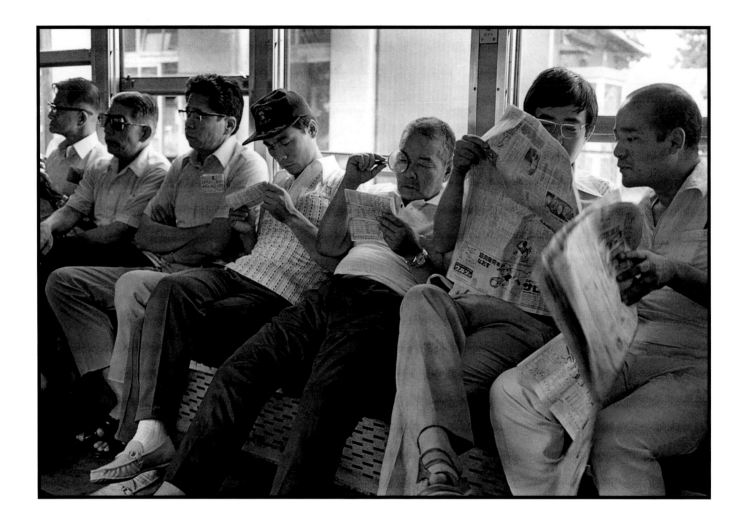

COMMUTER TRAIN, TOKYO, 1978

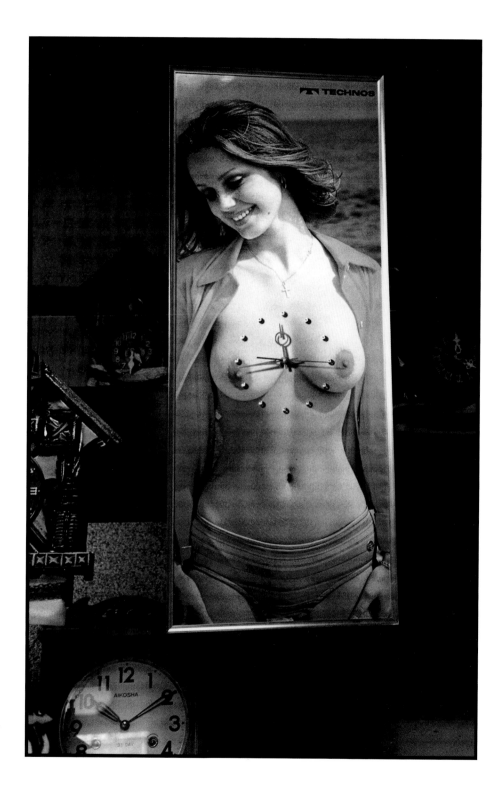

CLOCK STORE WINDOW, FUSSA, JAPAN, 1978

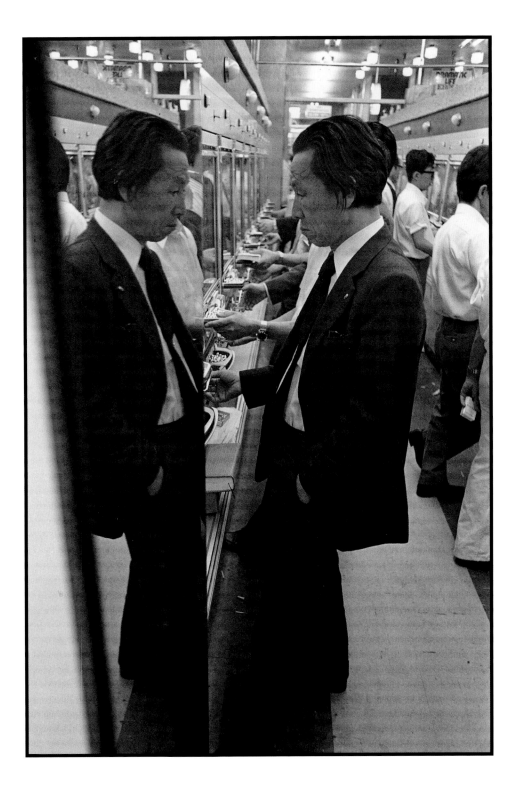

PACHINKO PARLOR, FUSSA, JAPAN, 1975

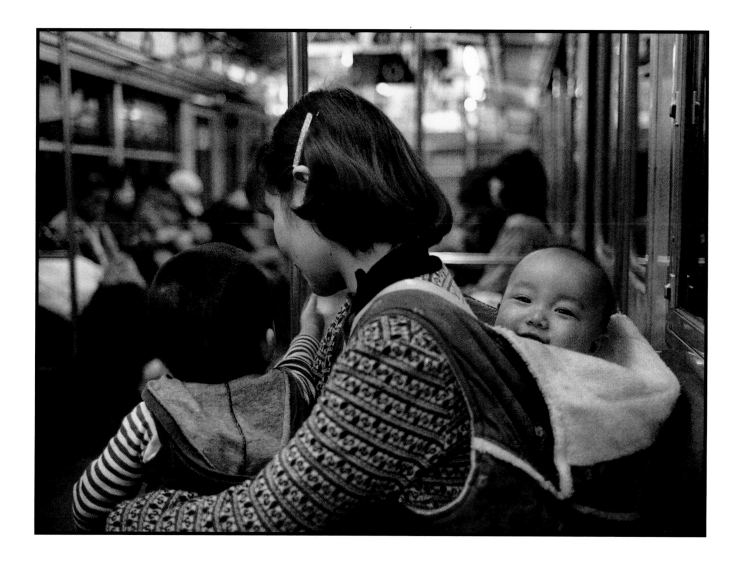

TOKYO, 1979

SAN ANSELMO, CALIFORNIA, 1982

A major winter storm prevented me from reaching the airport for a scheduled trip. The interruption provided an opportunity for some neighborhood photography.

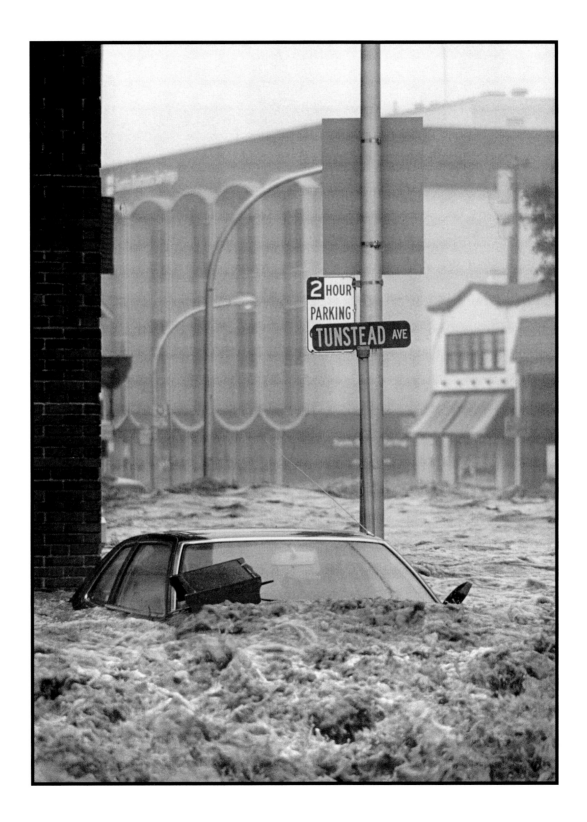

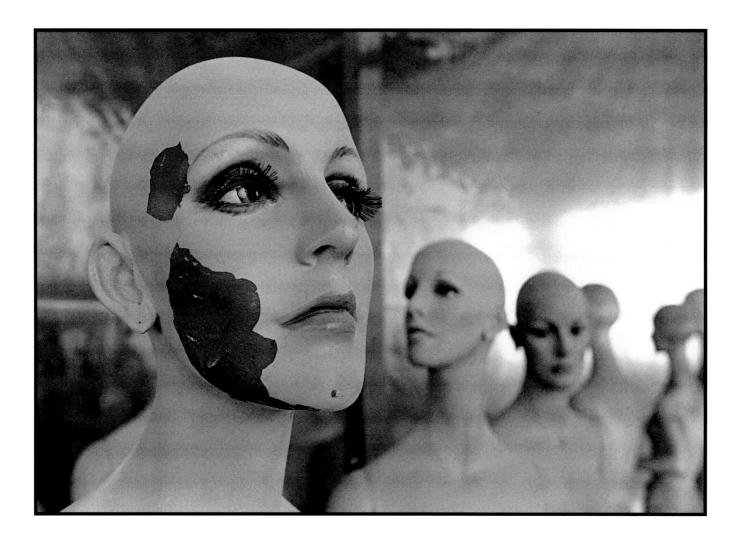

SAN FRANCISCO, 1979

On a solitary stroll through a mannequin warehouse, I came across this imperfect beauty
and felt a trace of sympathy. In the eerie after-hours silence, hundred of eyes followed me
whenever my back was turned. Surely they would talk about me when I was gone.

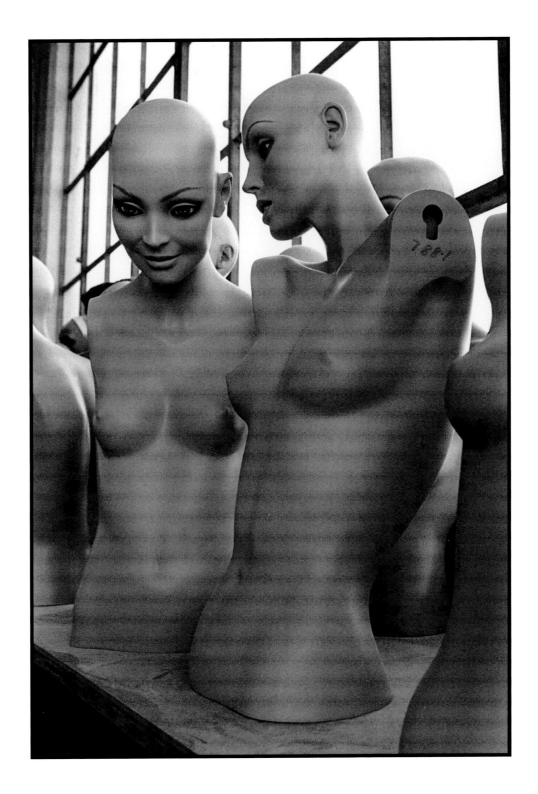

SAN FRANCISCO, 1979

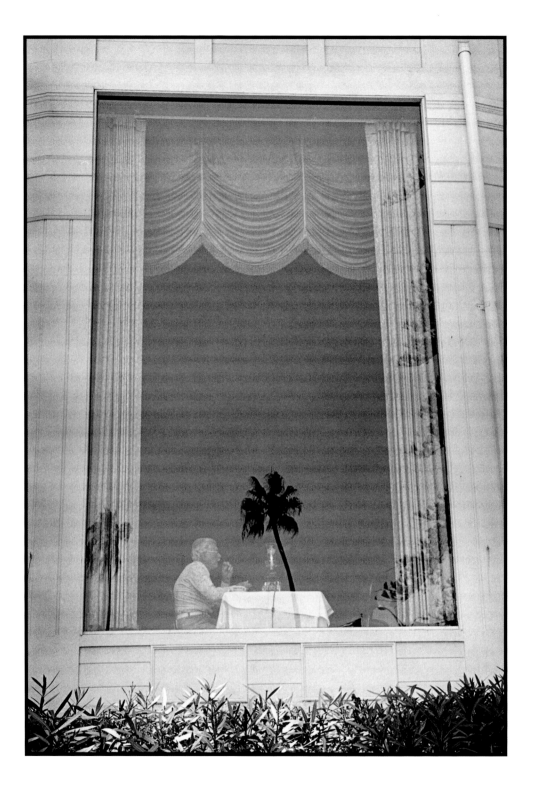

HOTEL DEL CORONADO, SAN DIEGO, 1981

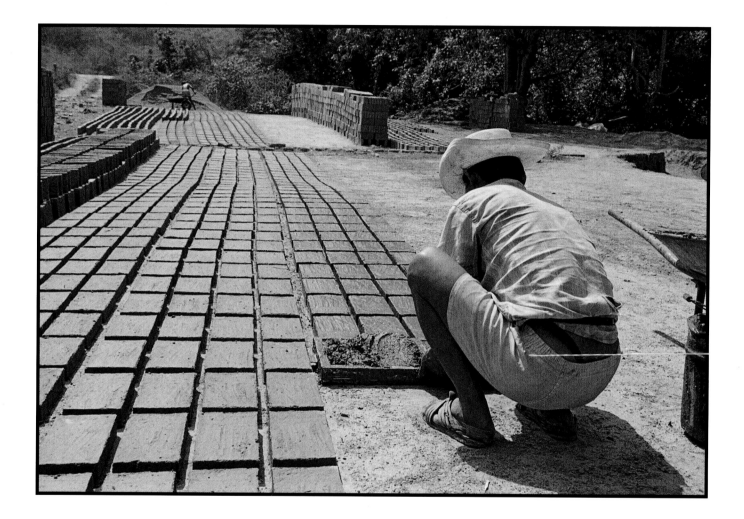

MANZANILLO, MEXICO, 1978

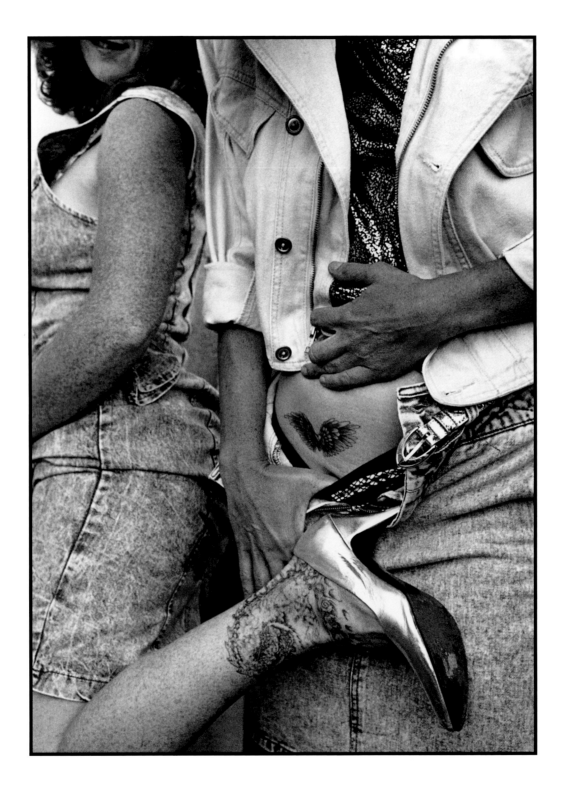

OAKLAND, 1988

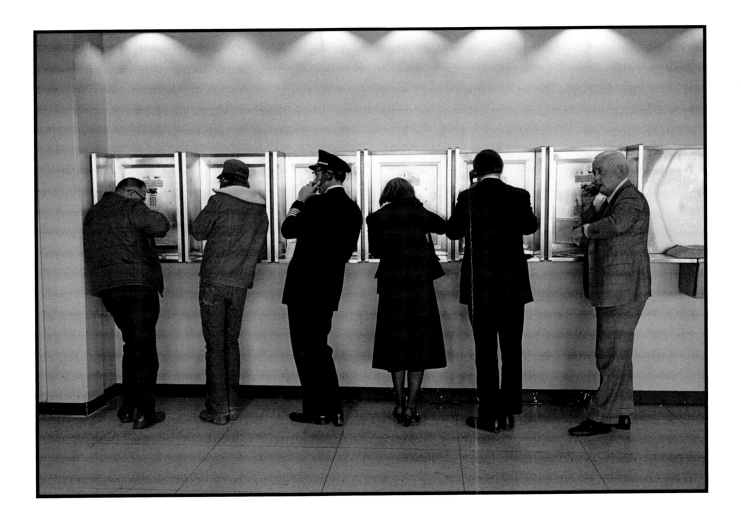

SAN FRANCISCO INTERNATIONAL AIRPORT, 1978

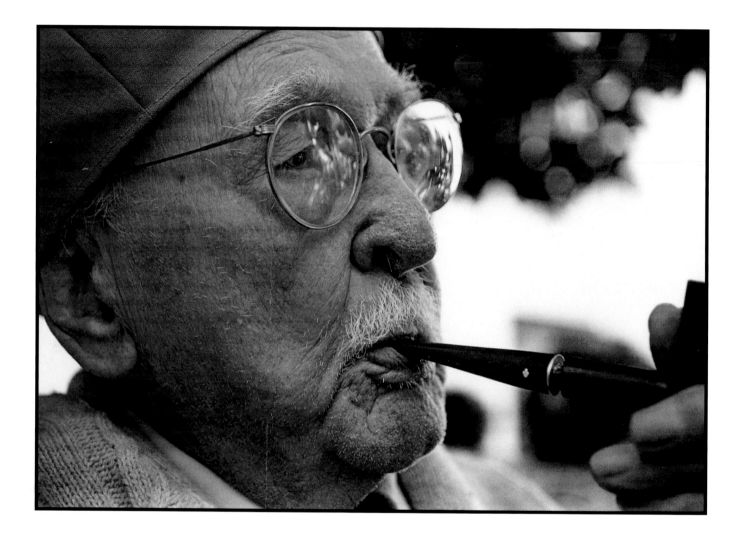

CHRIS MORTENSEN, SAN RAFAEL, CALIFORNIA, 1990

He was born Thomas Peter Thorvald Kristian Ferdinand Mortensen,
on August 16, 1882, in Skaarup, Denmark. Quite possibly the oldest
man who ever lived, he died peacefully in his sleep, April 25, 1998.
He attributed his longevity to clean living and 18 to 20 glasses of water
a day. He was married once, but couldn't remember her name.

SAN ANSELMO, CALIFORNIA, 1994

SAN ANTONIO, 1981

Greg and his parents crossed my path as I was dashing out of my hotel to grab a

quick pre-departure lunch of green cheese enchiladas.

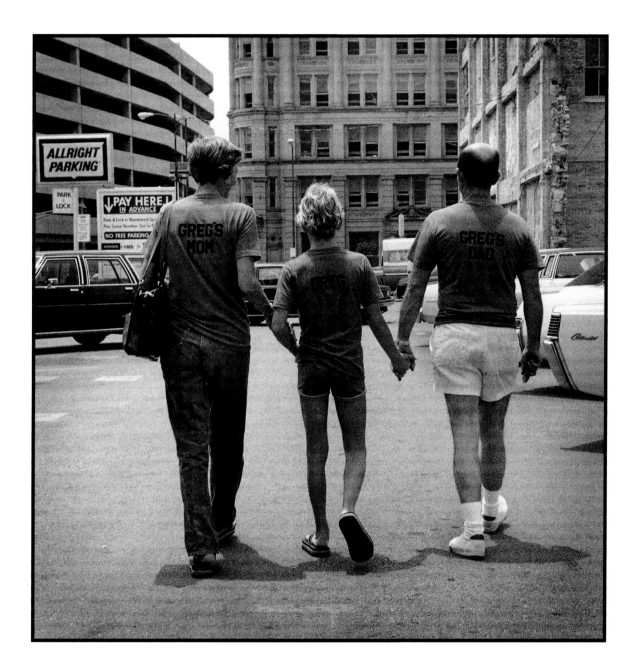

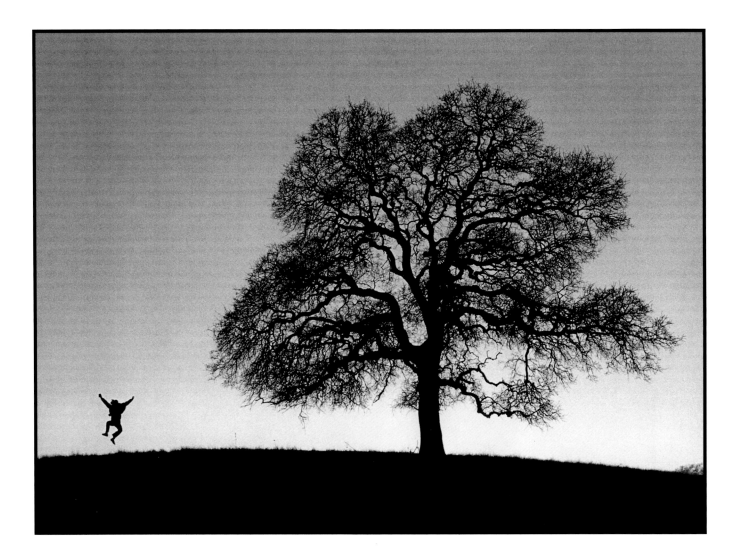

A spontaneous jump for joy in celebration of
the exhilarating magnificence of Mother Nature.

114

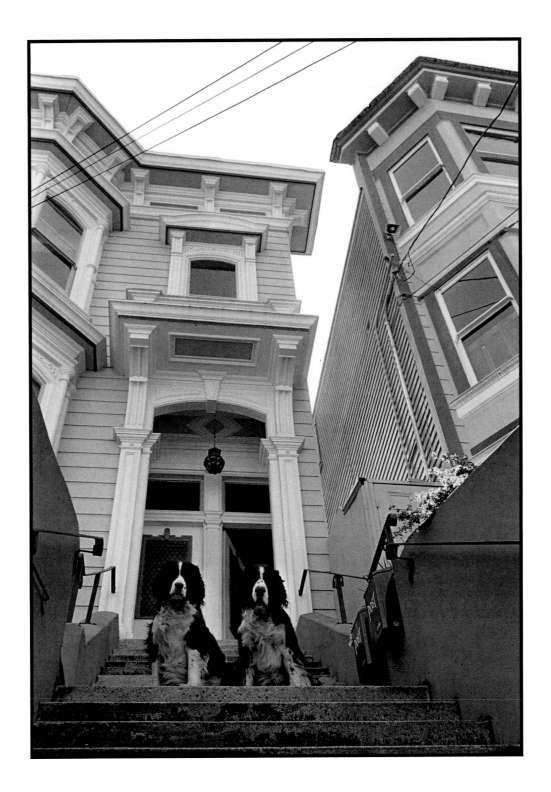

SAN FRANCISCO, 1984

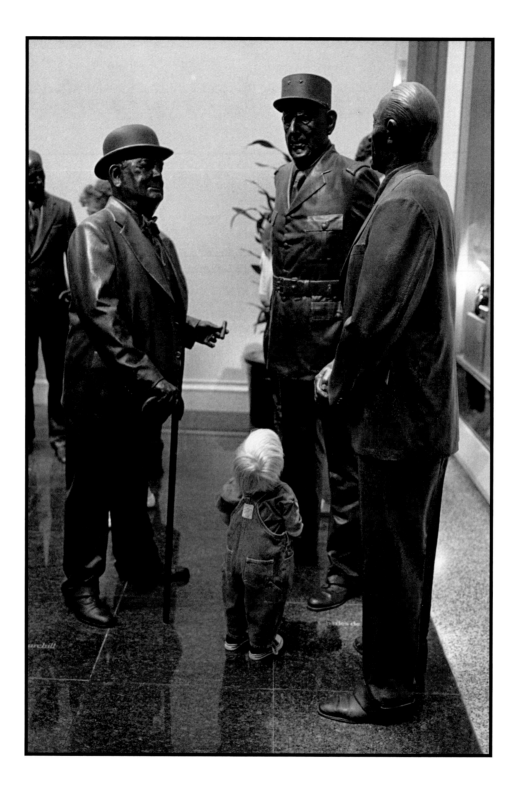

NIXON LIBRARY, WHITTIER, CALIFORNIA, 1995

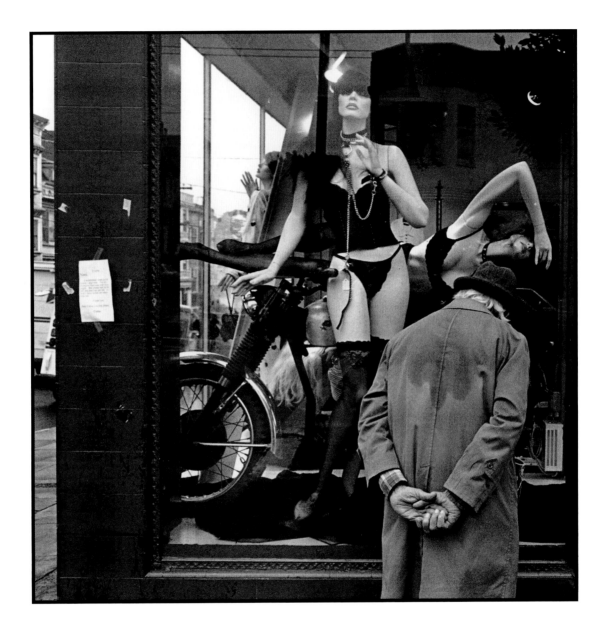

WINDOW SHOPPING, HAIGHT STREET, SAN FRANCISCO, 1996

BONNIE AND ME, SAN ANSELMO, CALIFORNIA, 1978

One of the nicest things about returning home after a long journey was the

enthusiastic welcome I would receive from my dog Bonnie. Always available to

help me finish off a roll of partially exposed film, she eventually became a

family wage earner as a Hallmark favorite for their "Lovable Mutts" calendars.

Not bad for a Humane Society $10.00 special.

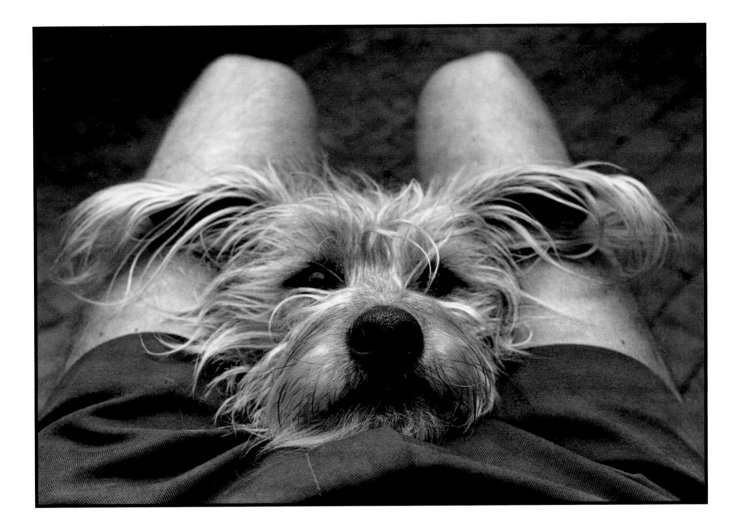